Fabulous Flowers
Grayscale Coloring Book for Adults
by Ronda Francis

Colored by

Introduction

Welcome back to my flower garden. I have taken my love for gardening and photography and combined it with my passion for coloring to bring you 36 of my original flower photos. Inside you'll discover lilies, peonies, daisies, black-eyed Susan, apple, dicentra, magnolia, honeysuckle, start of Bethlehem, calibrachoa, phlox, narcissus, iris, oenothera, cuphea, azalea, columbine, helebore, bacopa, oxalis, begonia, daffodil, osteospermum, scaevola, rose, hyacinth, lilac and houttuynia.

Tips for coloring grayscale

Color highlight areas first using pale tones, followed by medium tones of the same color range in adjoining areas to blend into the light areas. Use darker tones to color shadows, blending into the medium tones. You can also use a darker tone to outline the area colored. Colors that work well together are yellows, oranges and pale browns; light, medium and dark blues; pink, red and purple; and light, medium and dark greens. Avoid using colorless blending pencils which may drag the ink from the page into the colors you're using. Instead, try using a colorless blending marker, Gamsol, or a pencil in a lighter shade.

I hope you have fun coloring the photos and that you'll consider posting your fin ished pages in my Facebook group: Beautiful Blossoms Coloring Group, and in other coloring groups. Please do not share uncolored images as they are copyrighted.

Happy coloring!
Ronda

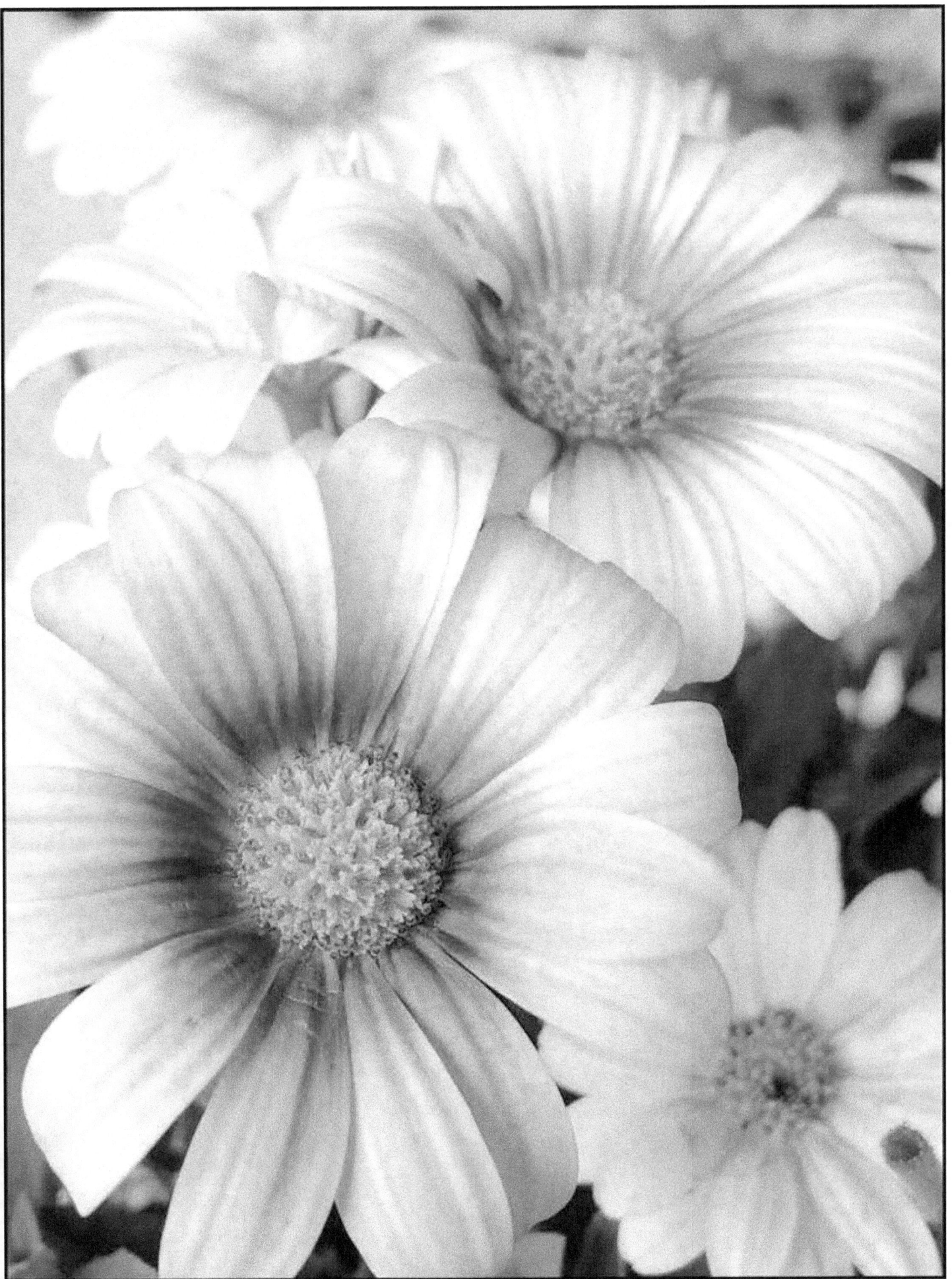

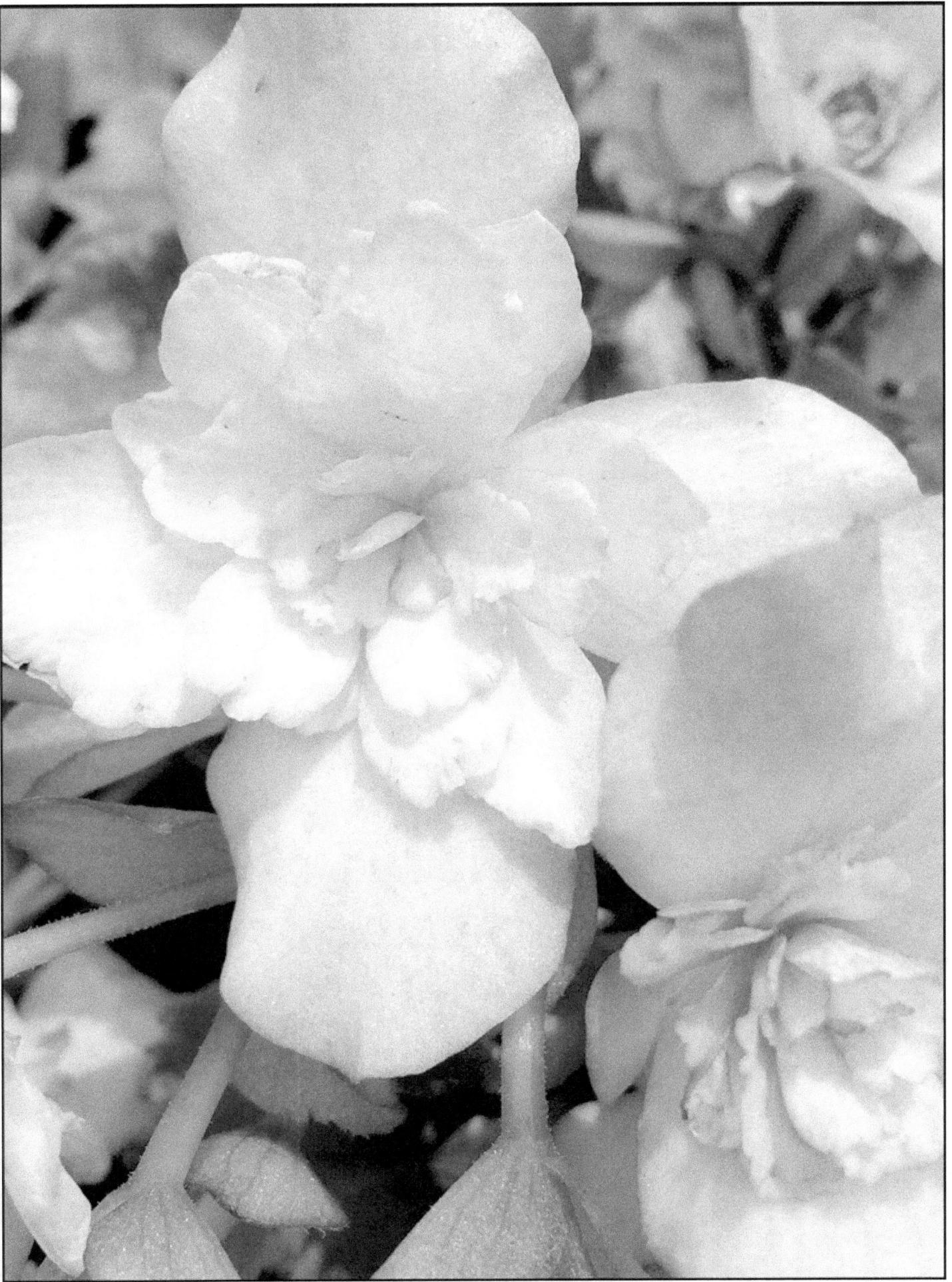

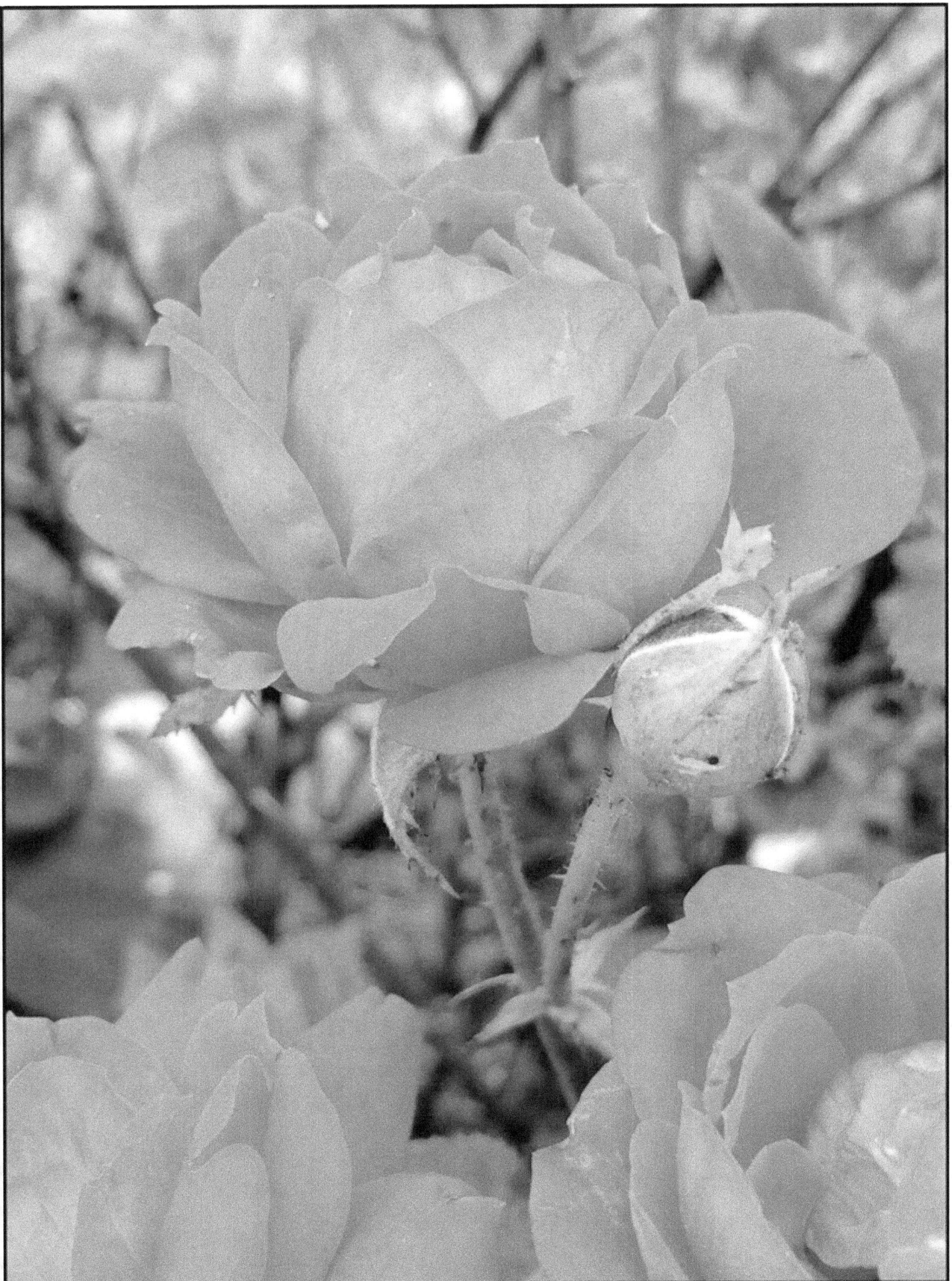

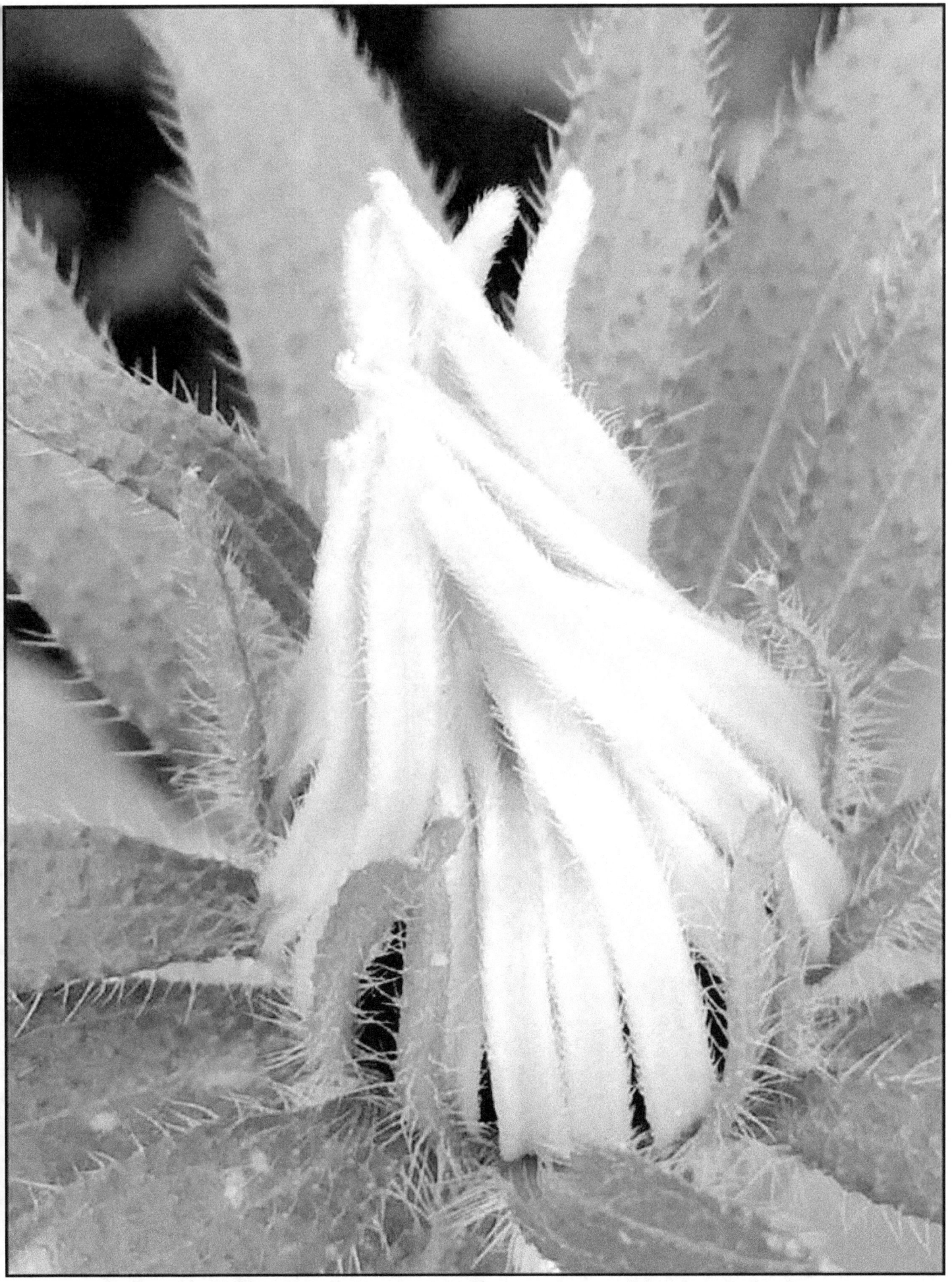

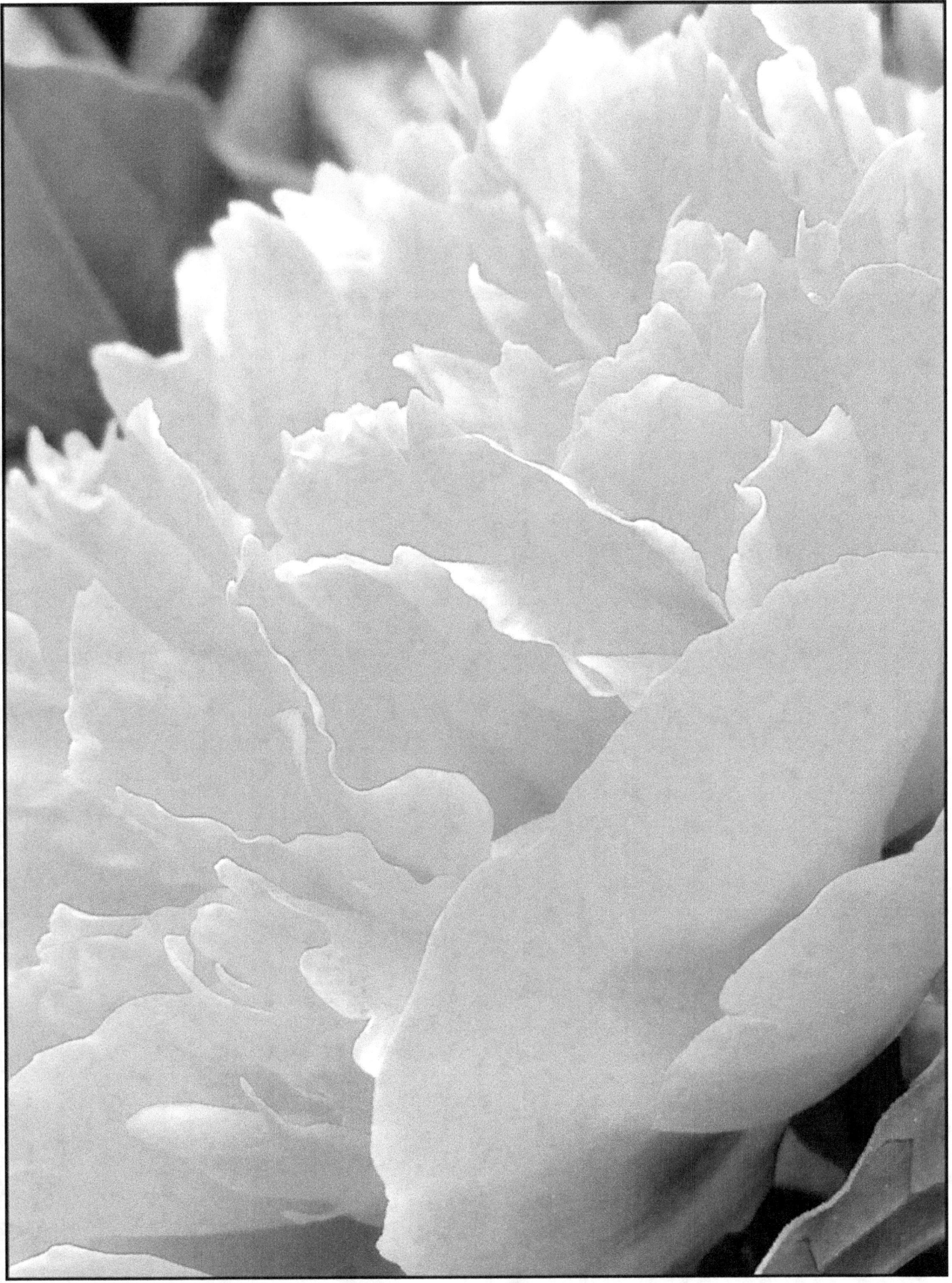

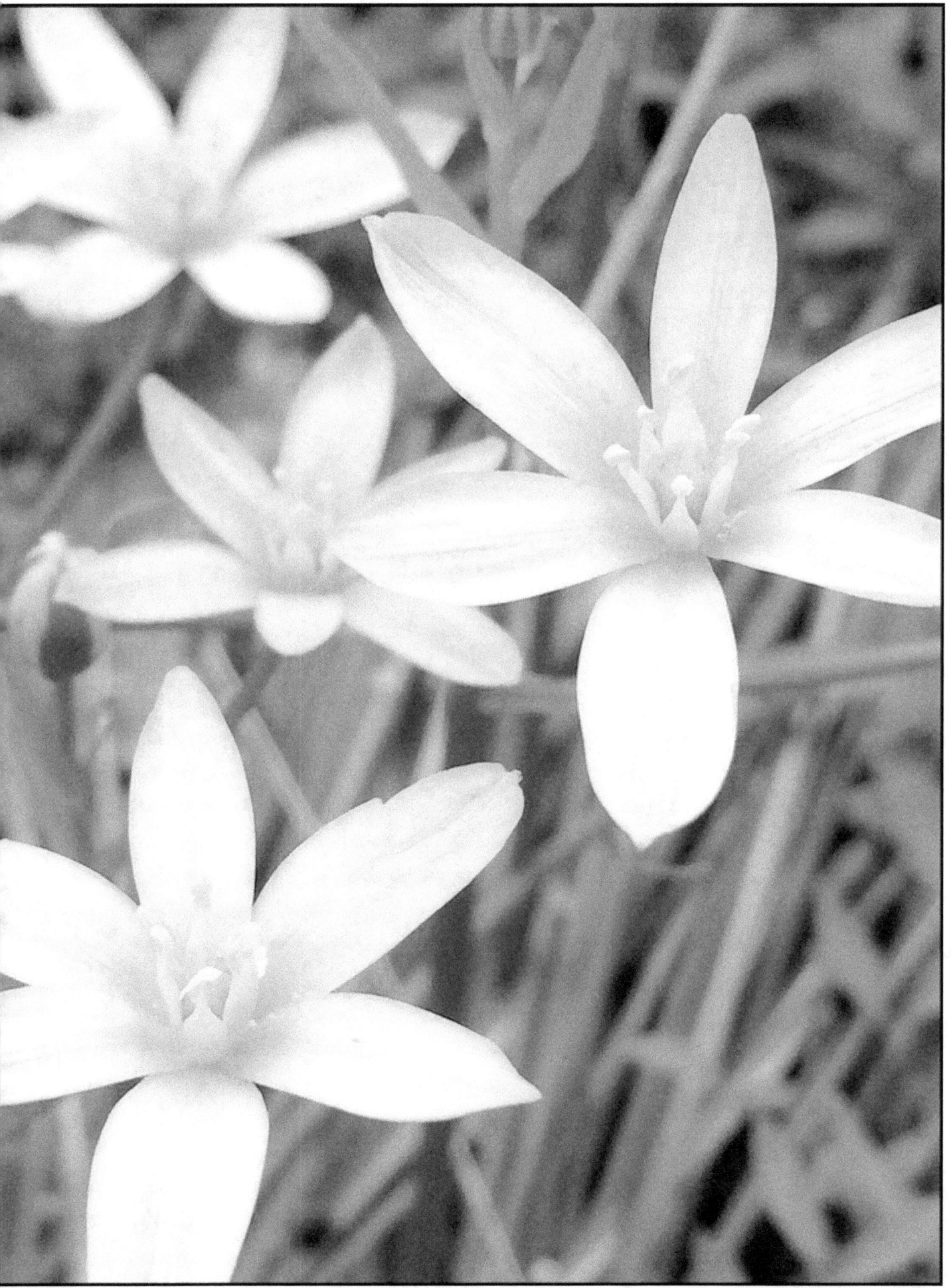

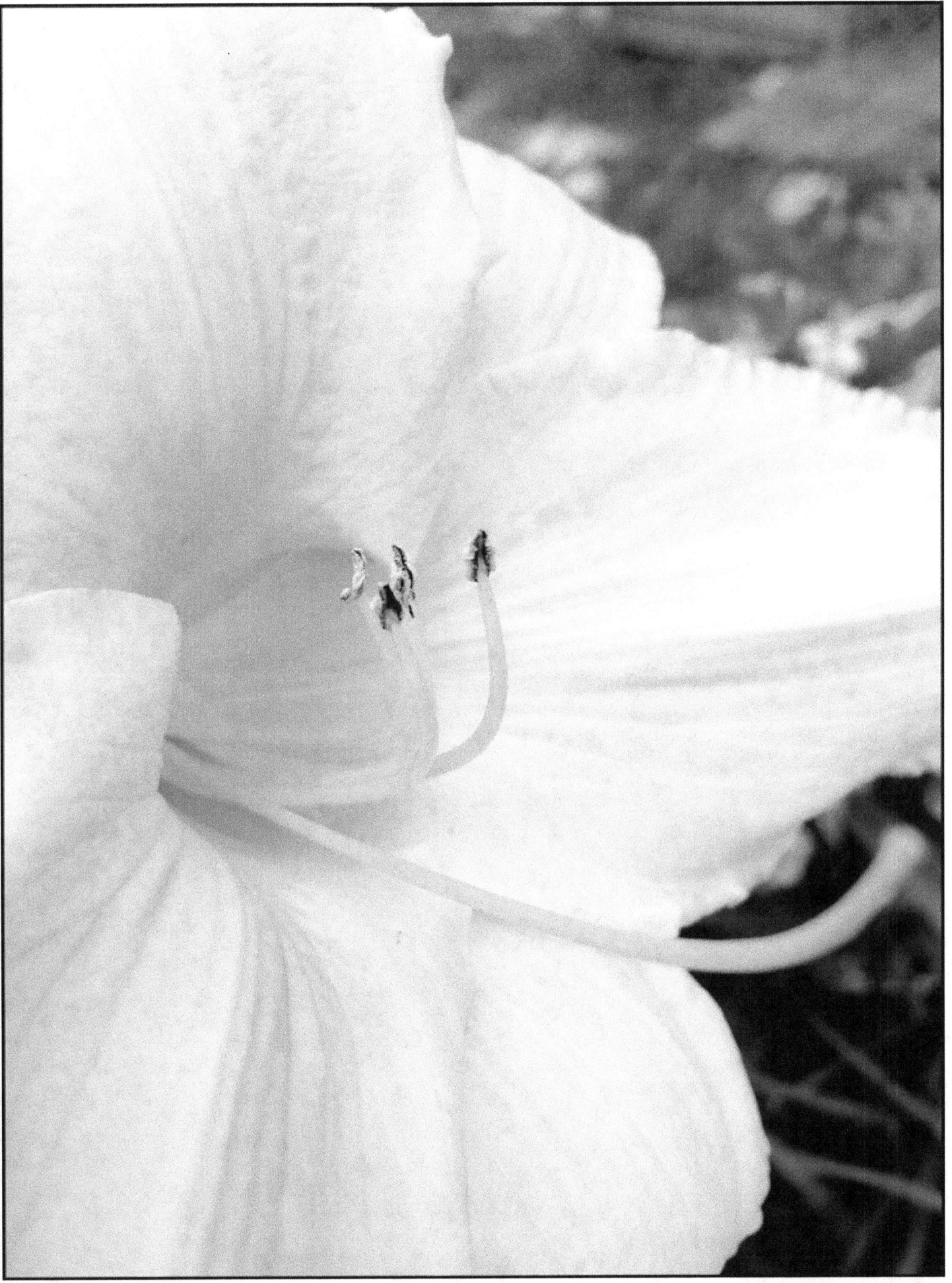

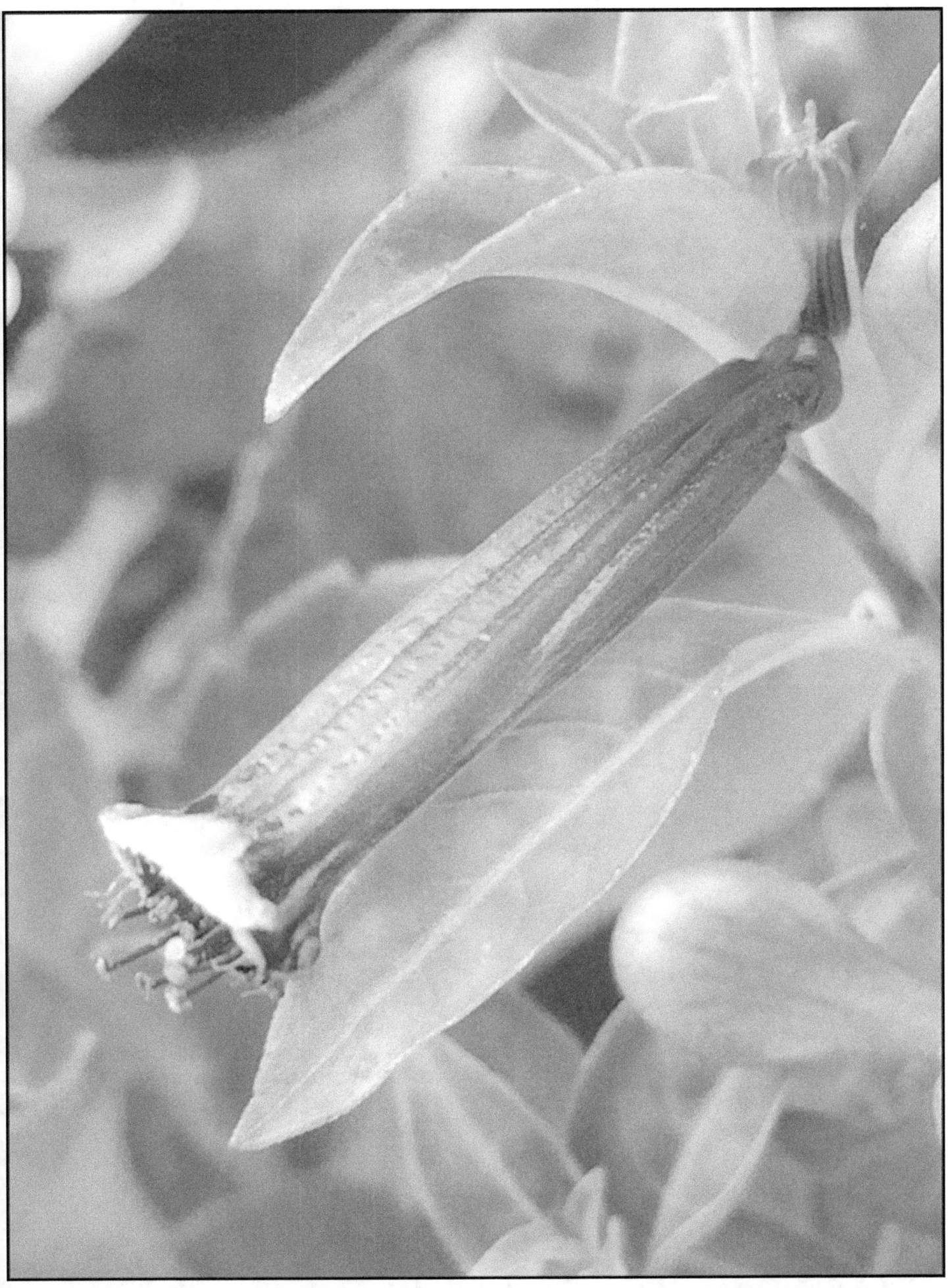

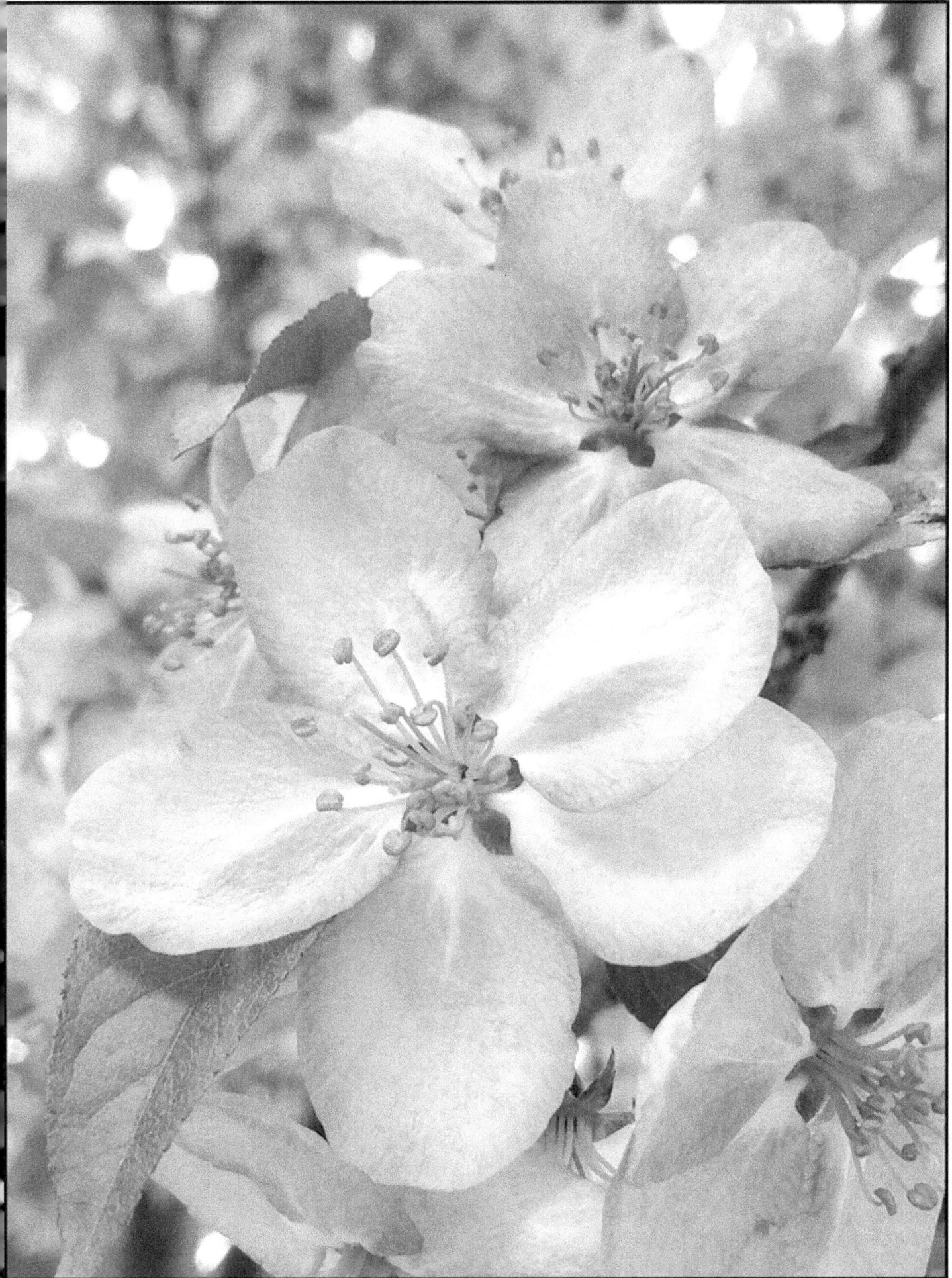

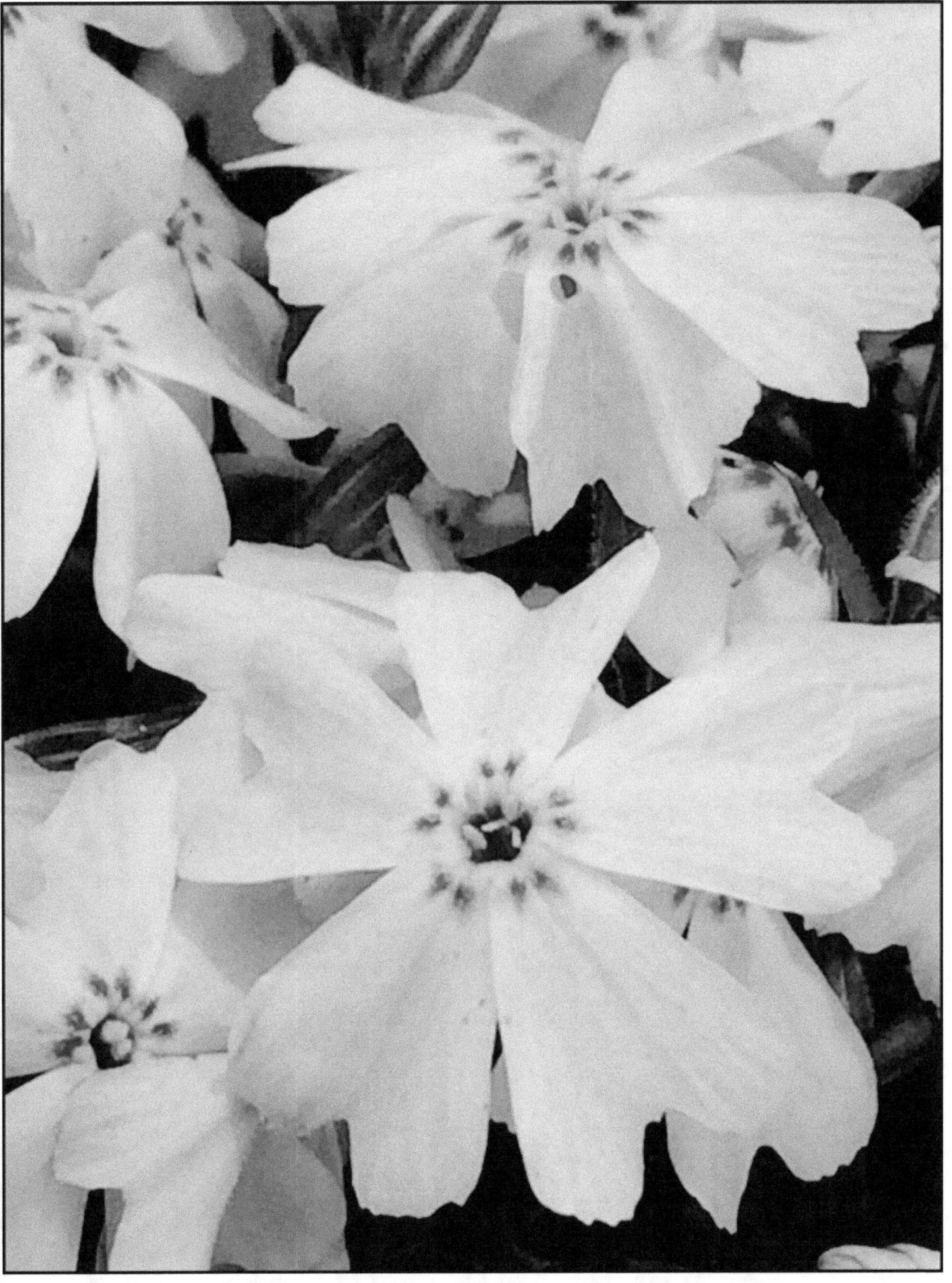

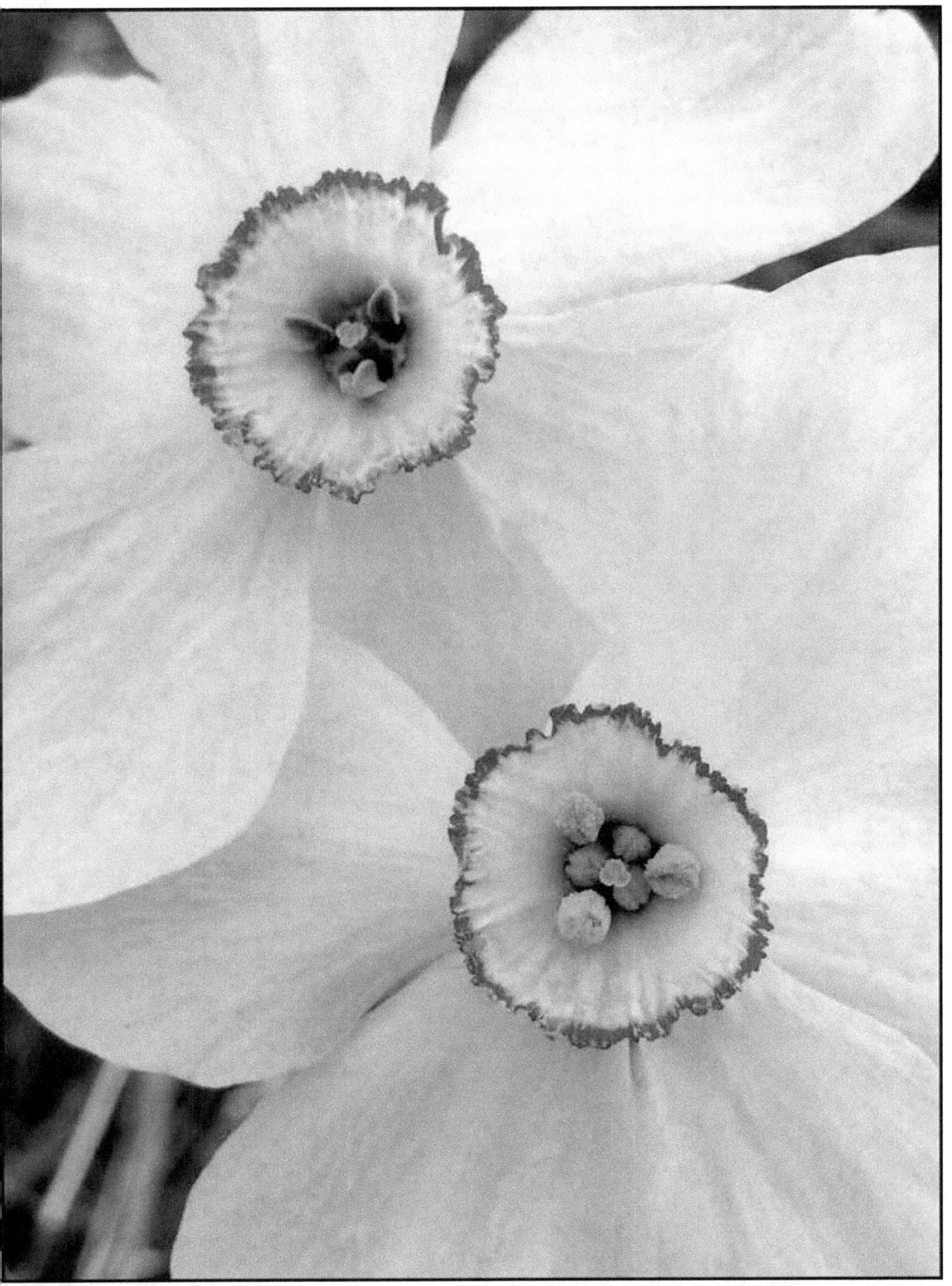

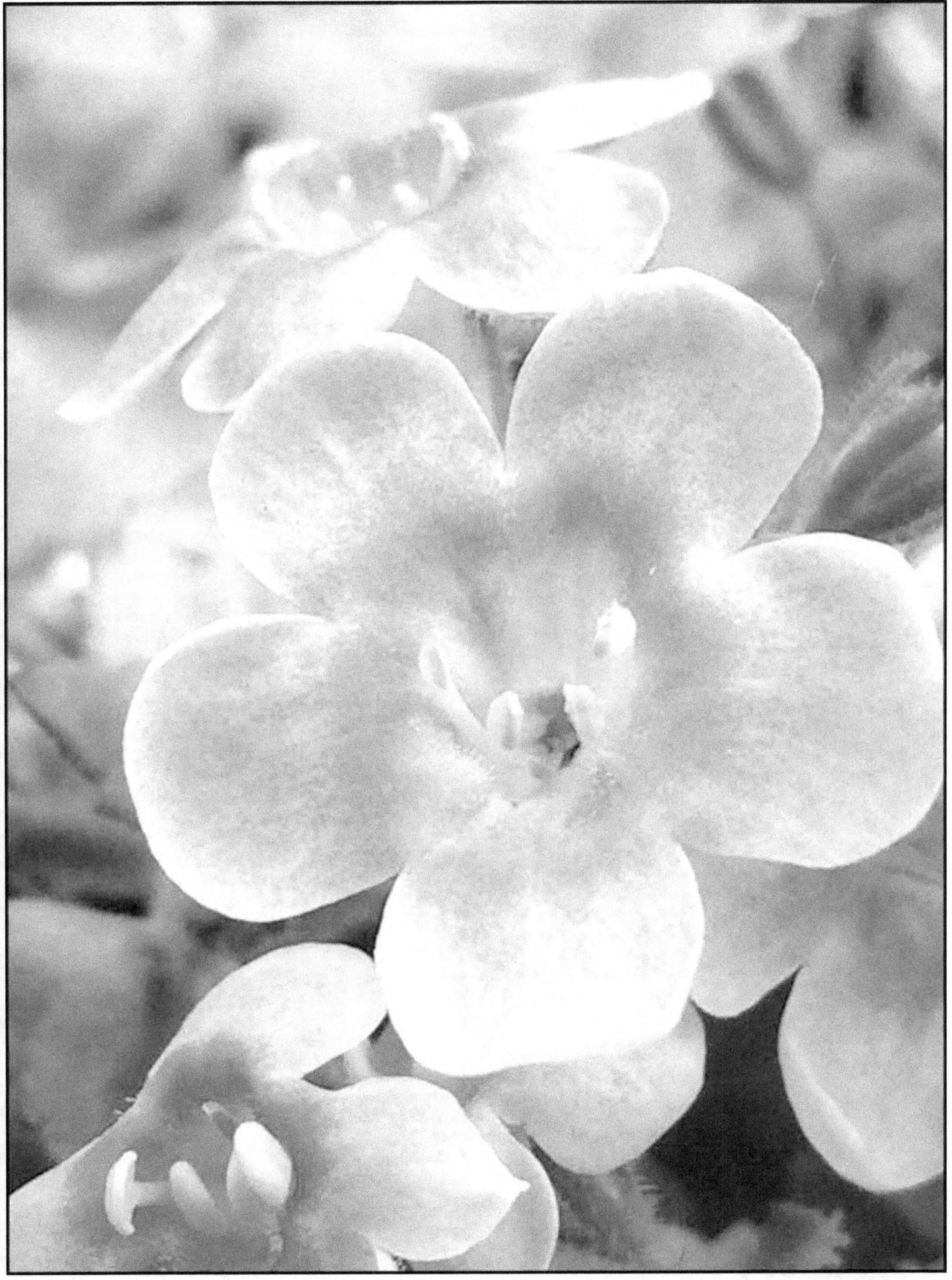

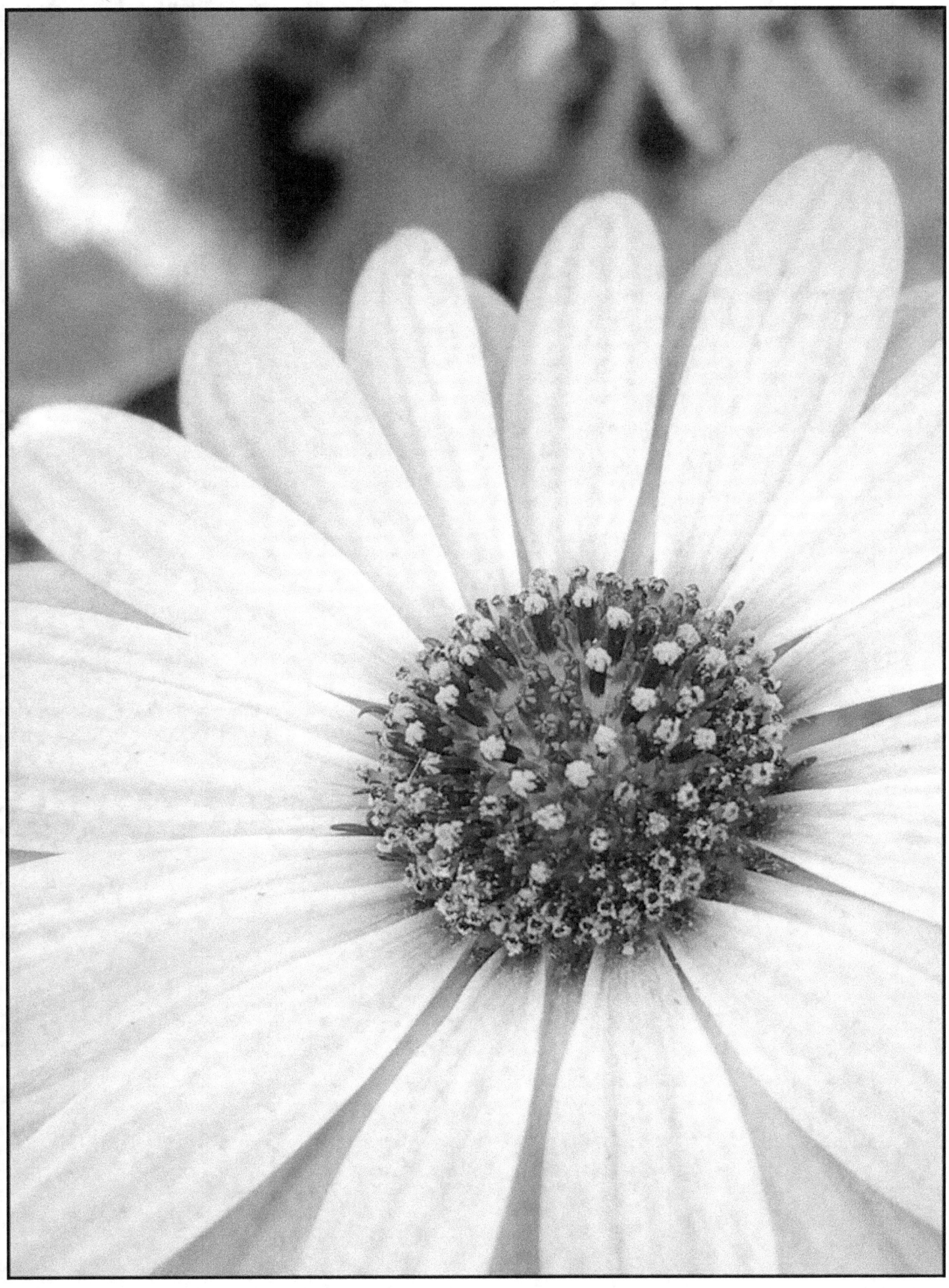

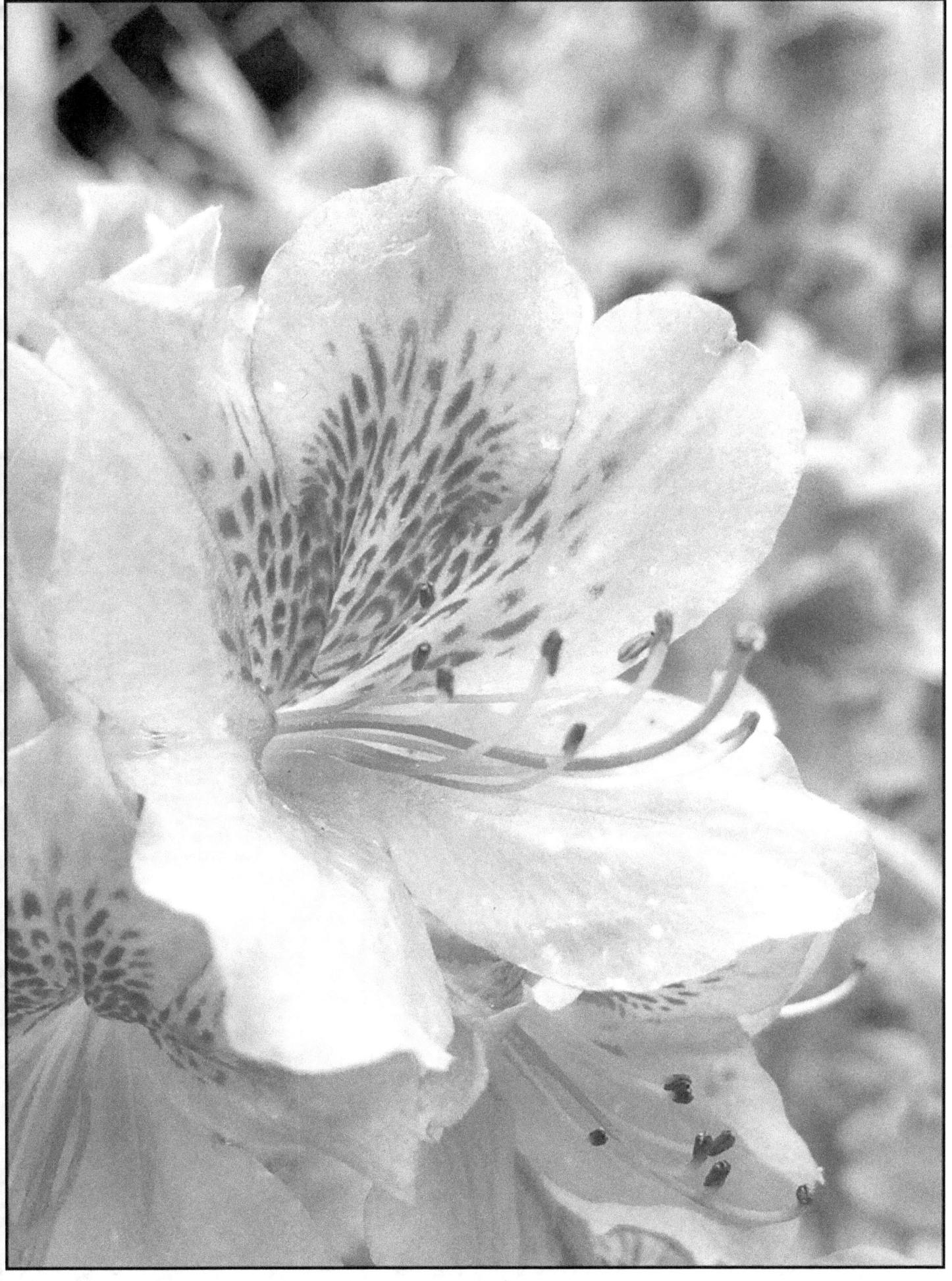

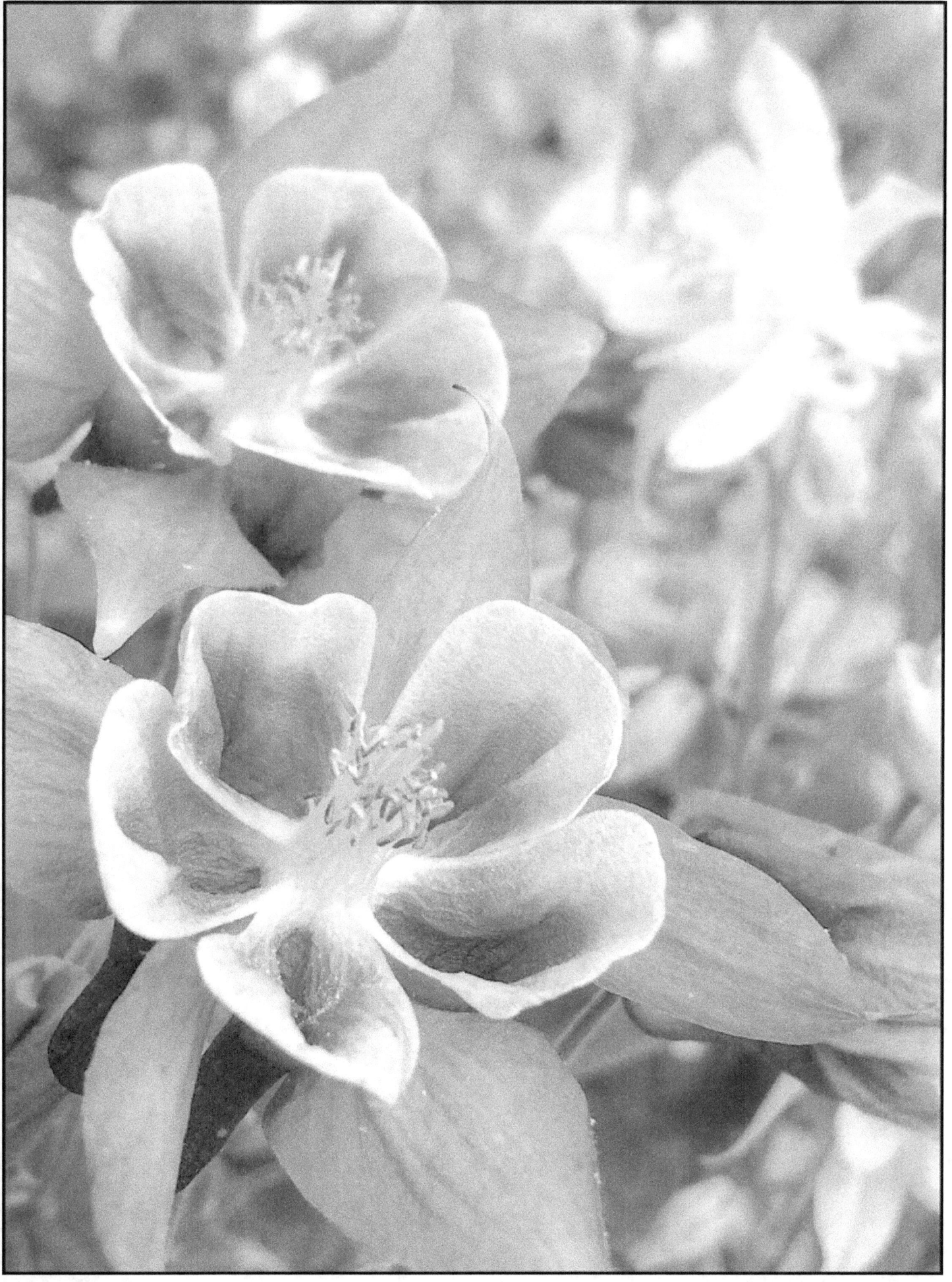

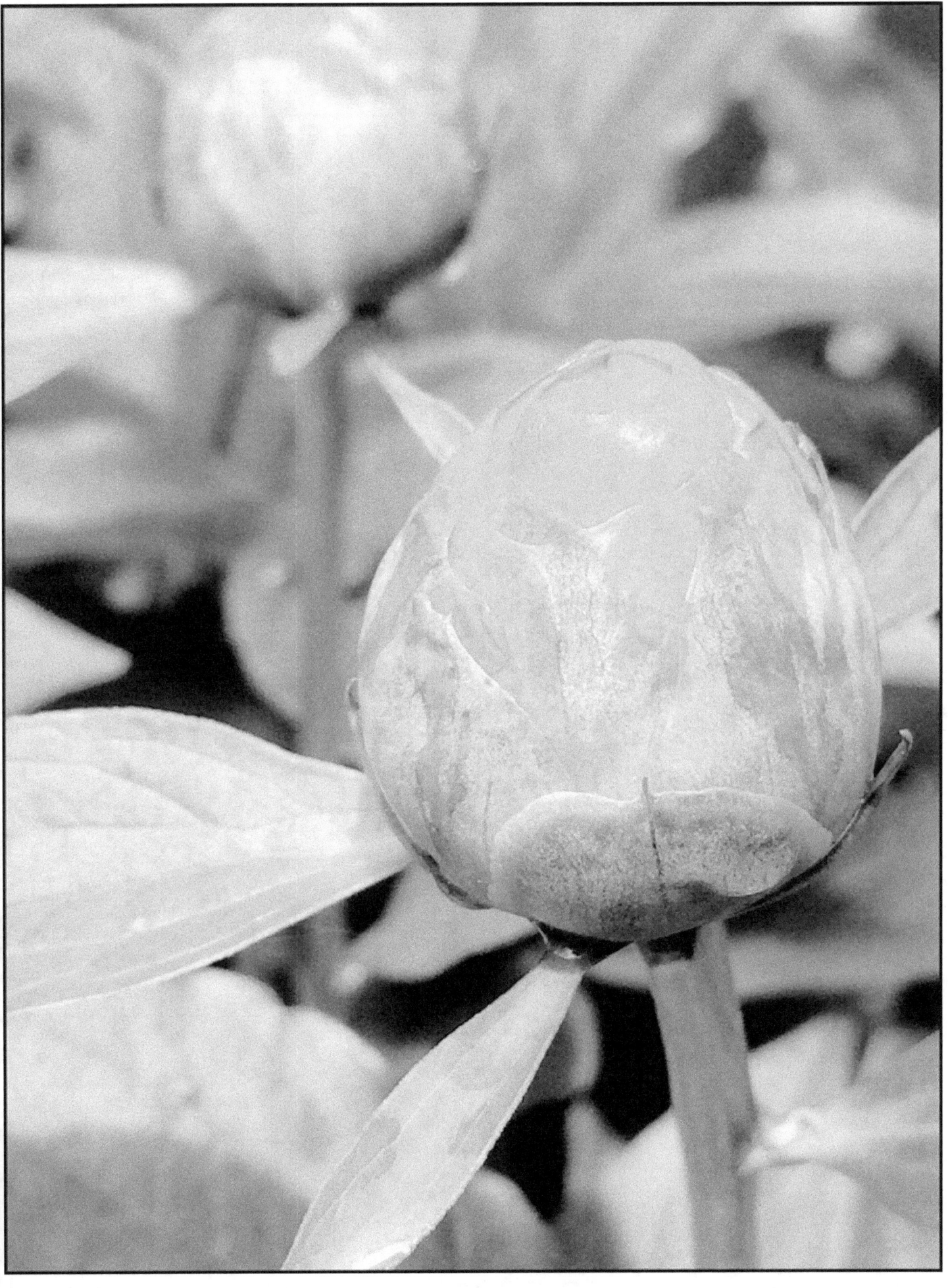

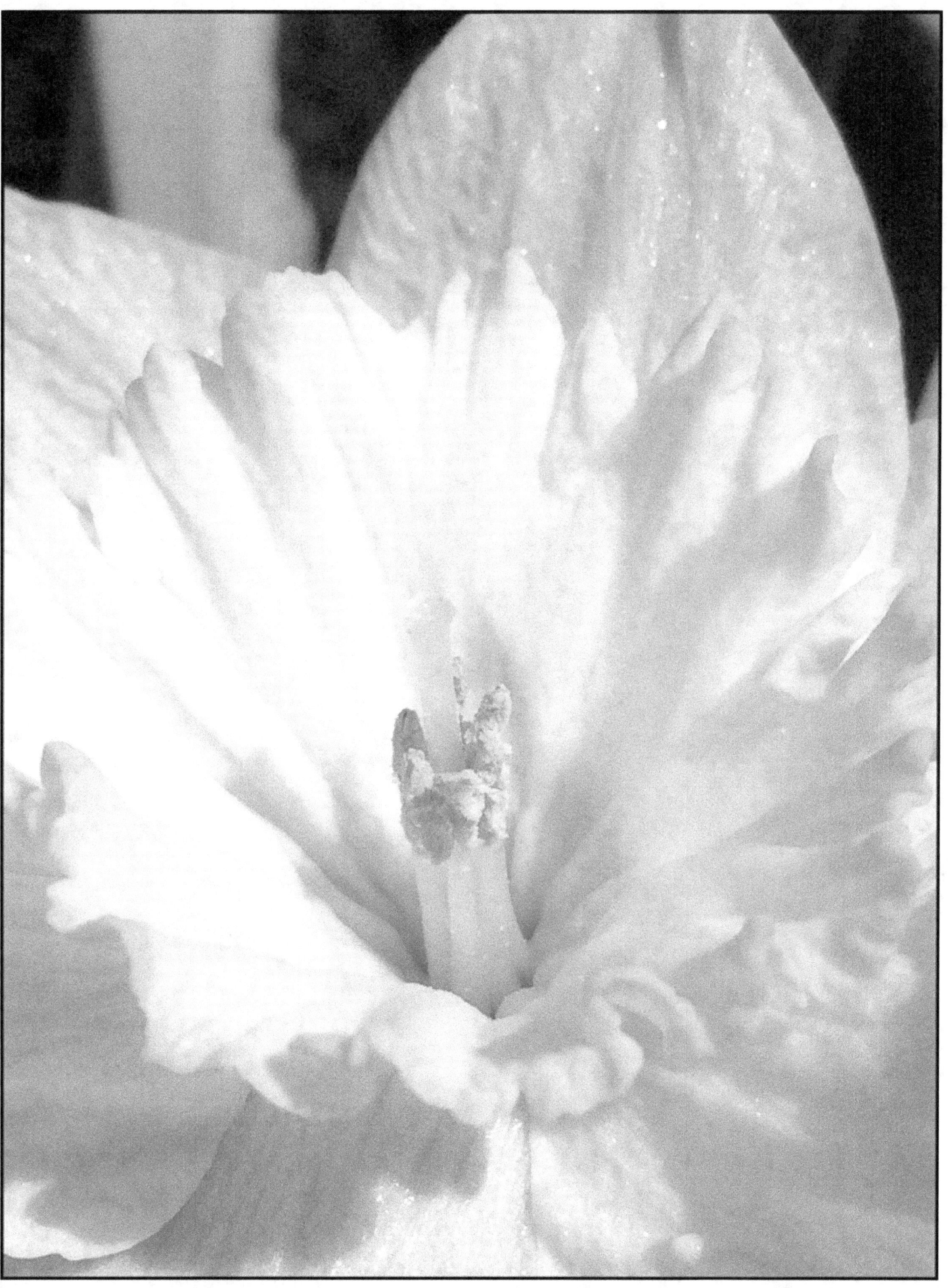

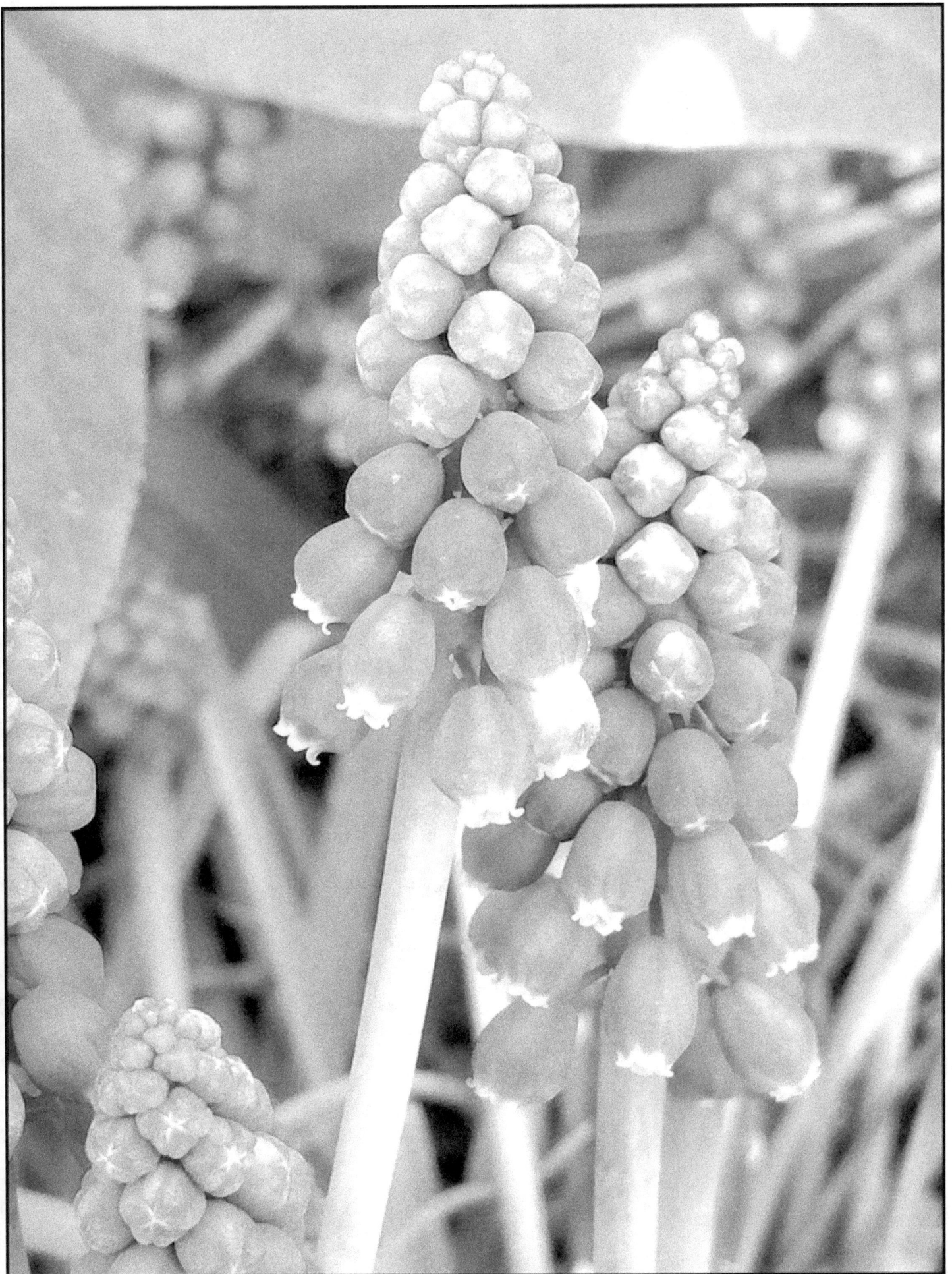

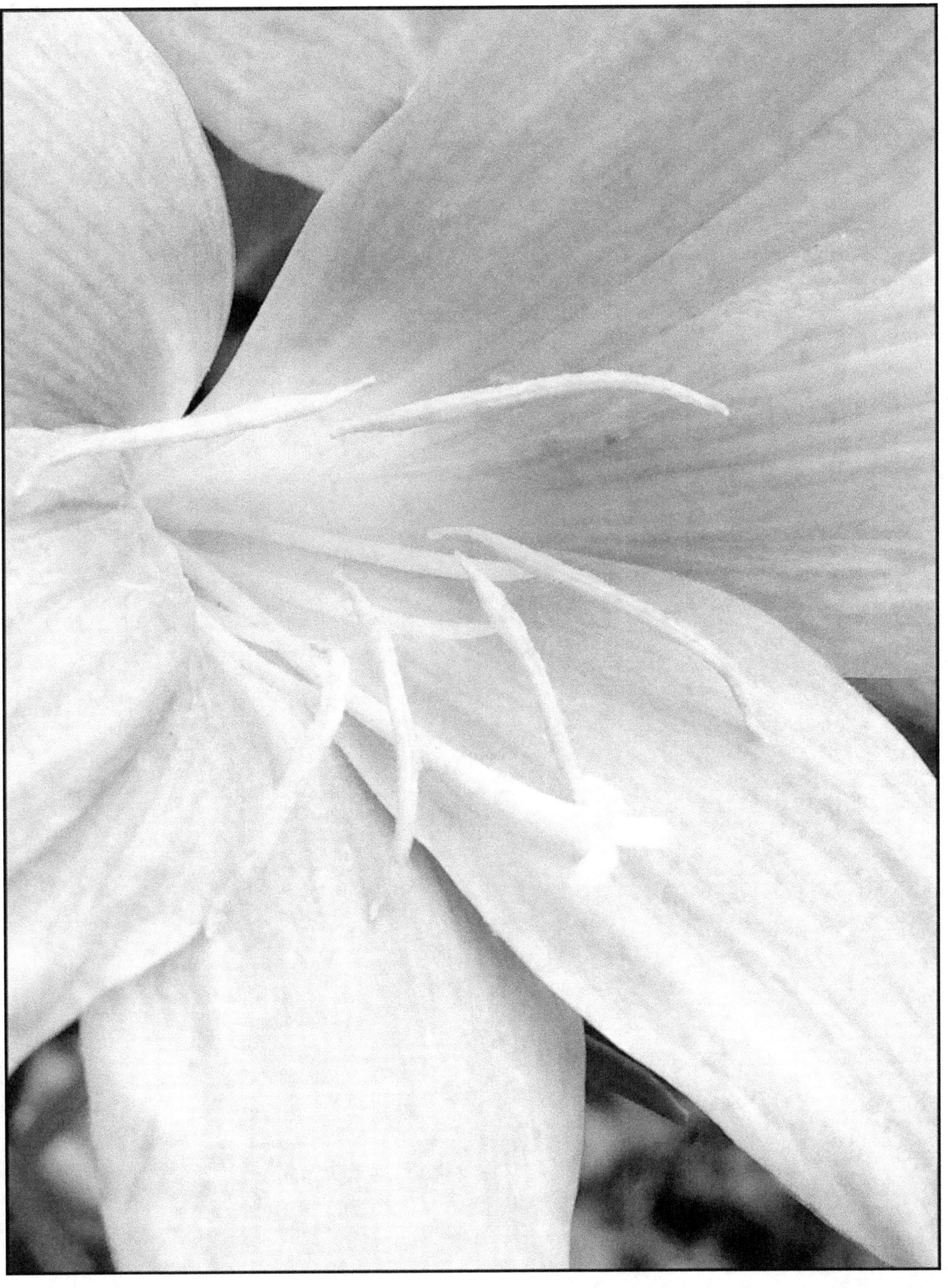

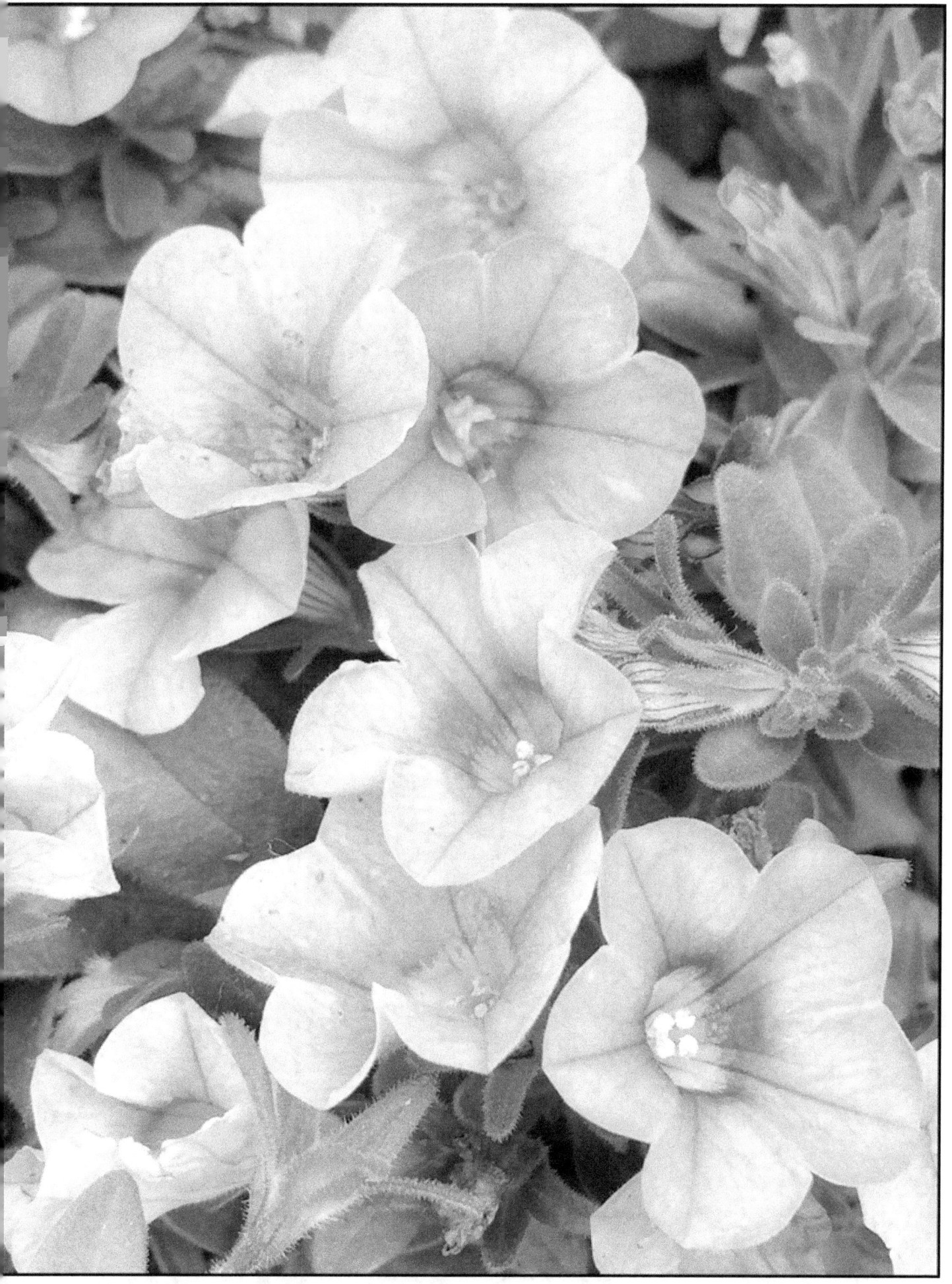

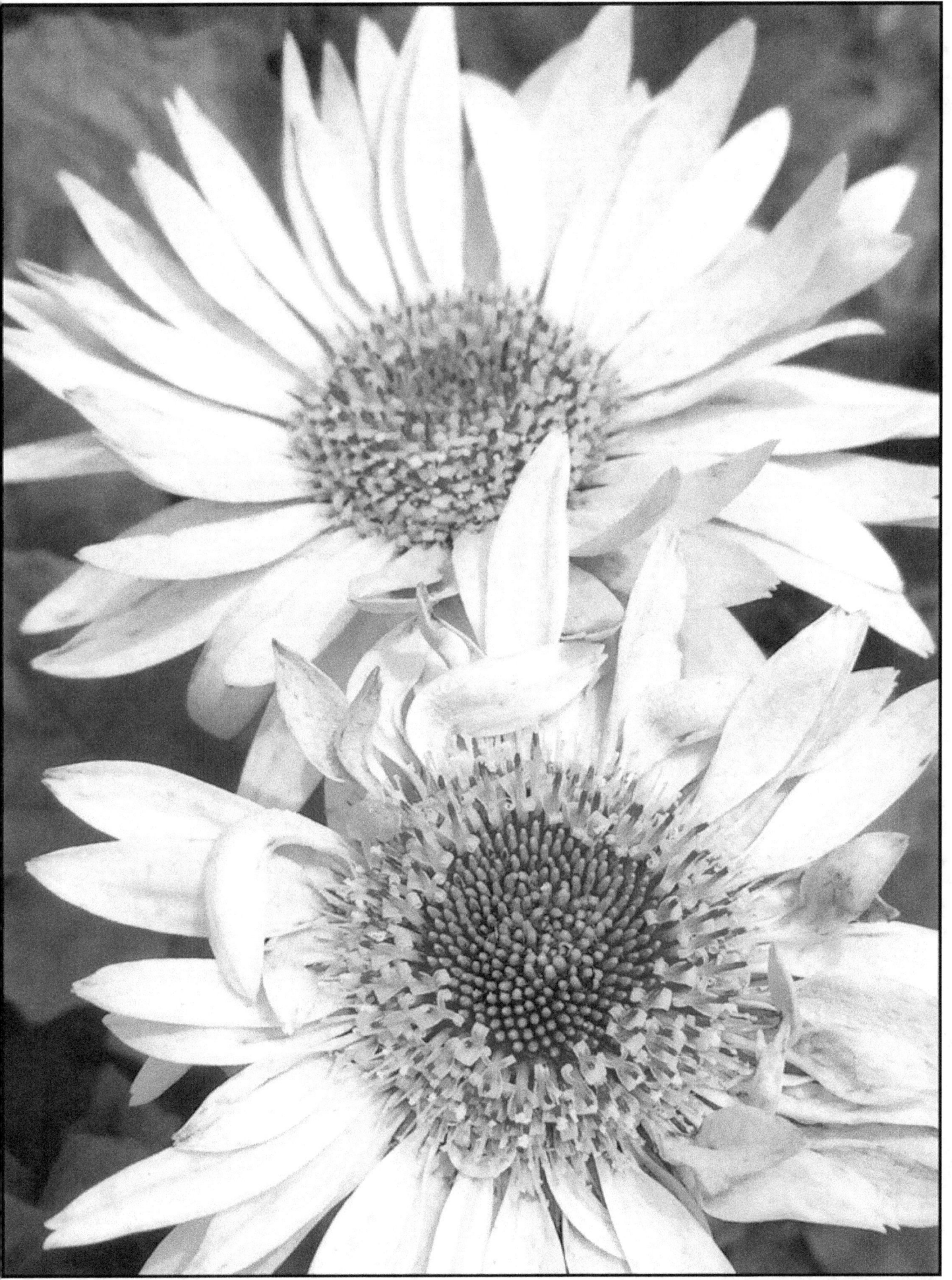

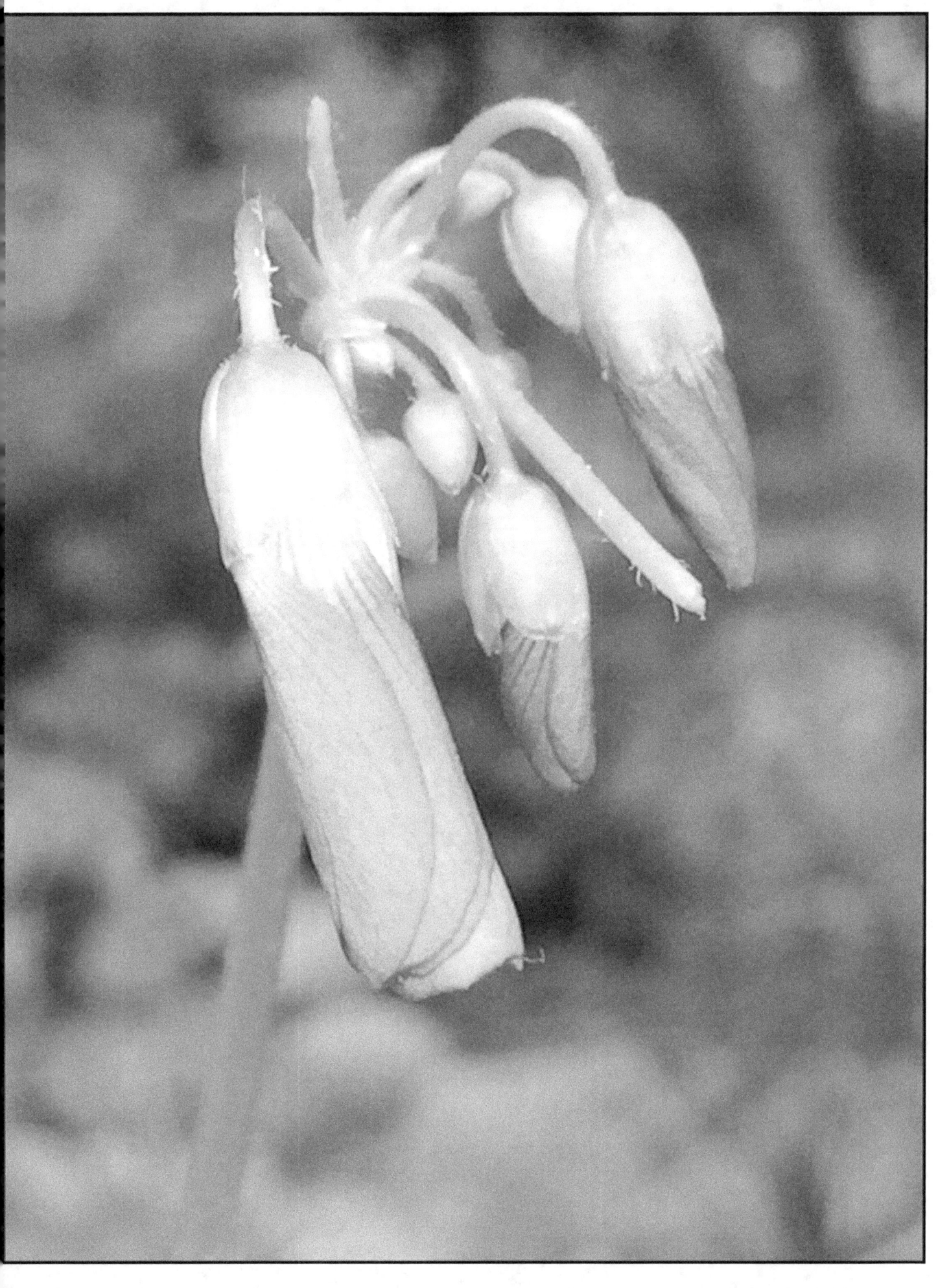

Horizontal Blossoms

The following photos are in a horizontal format, so turn the book sideways to work on the pictures in the correct orientation. (Because they are close-ups, sometimes it is difficult to tell which side is up!)

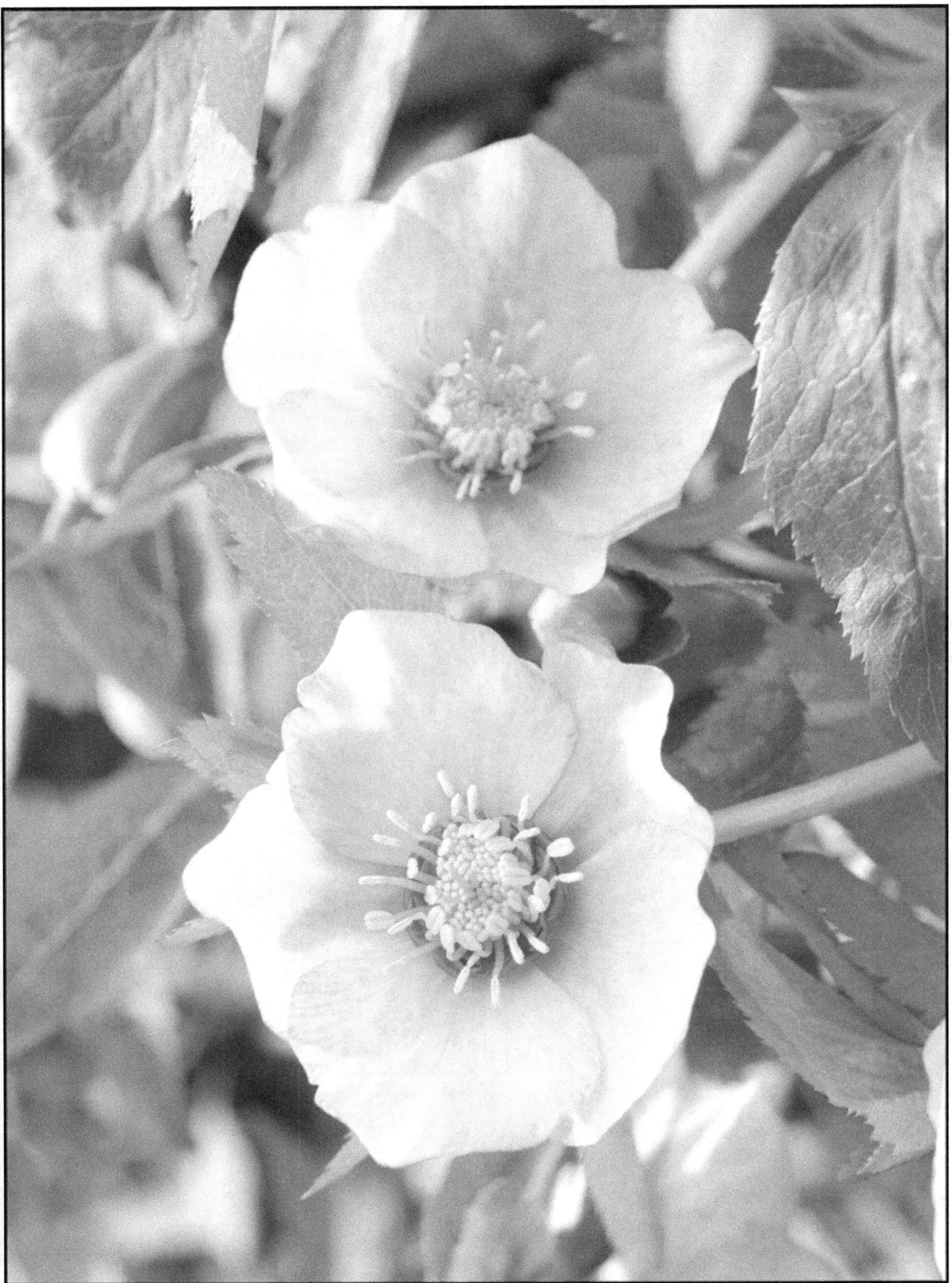

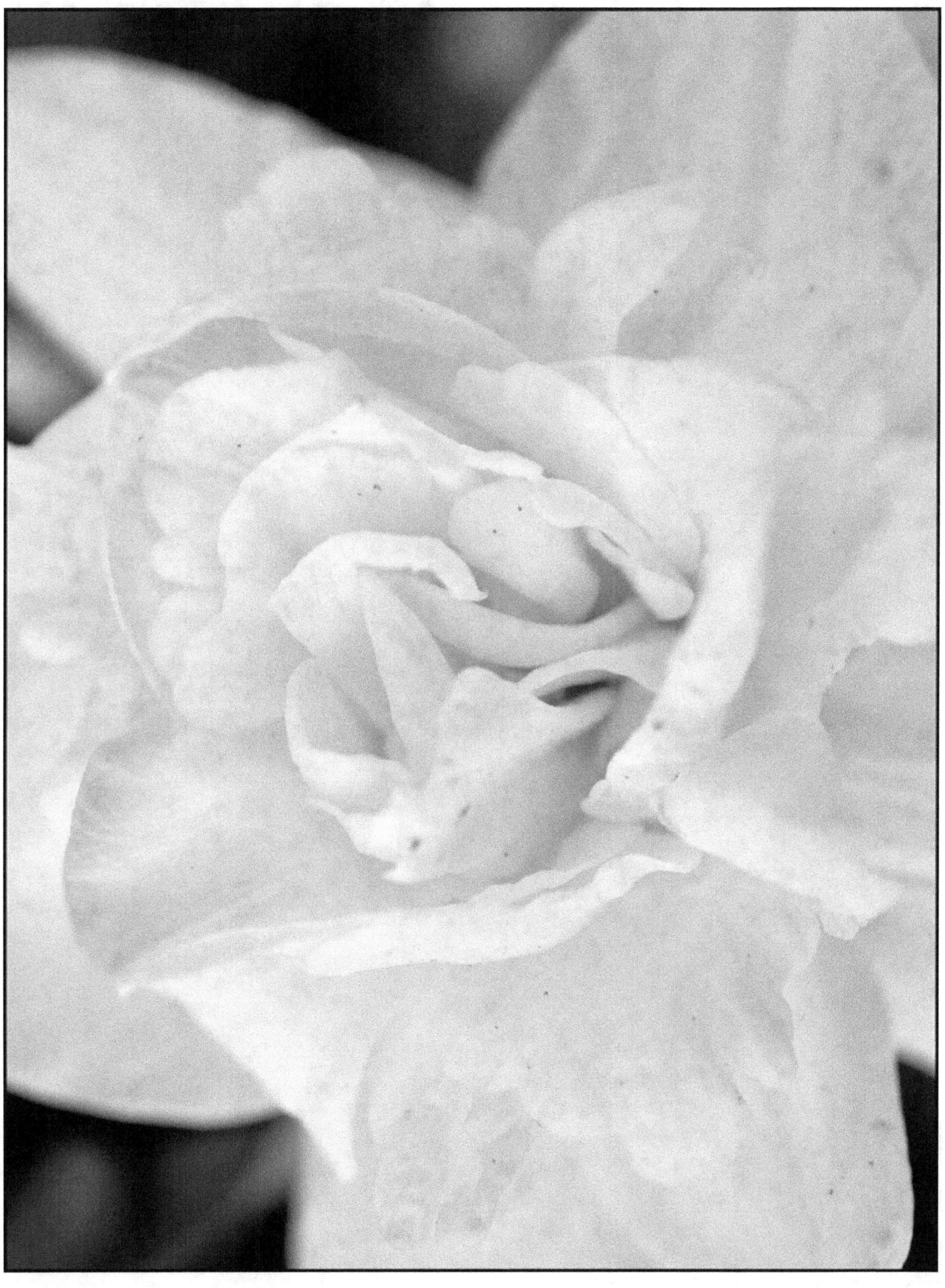

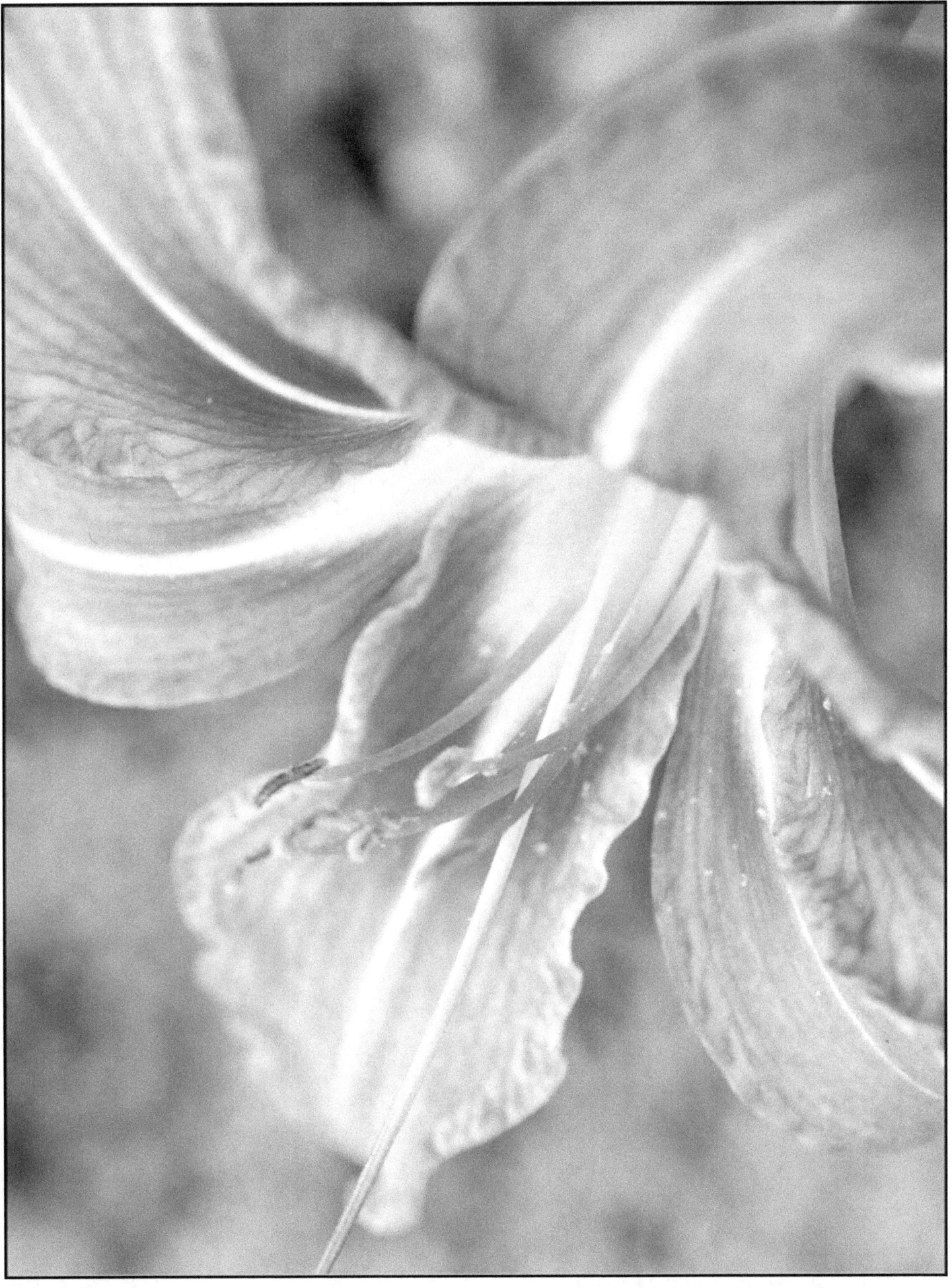

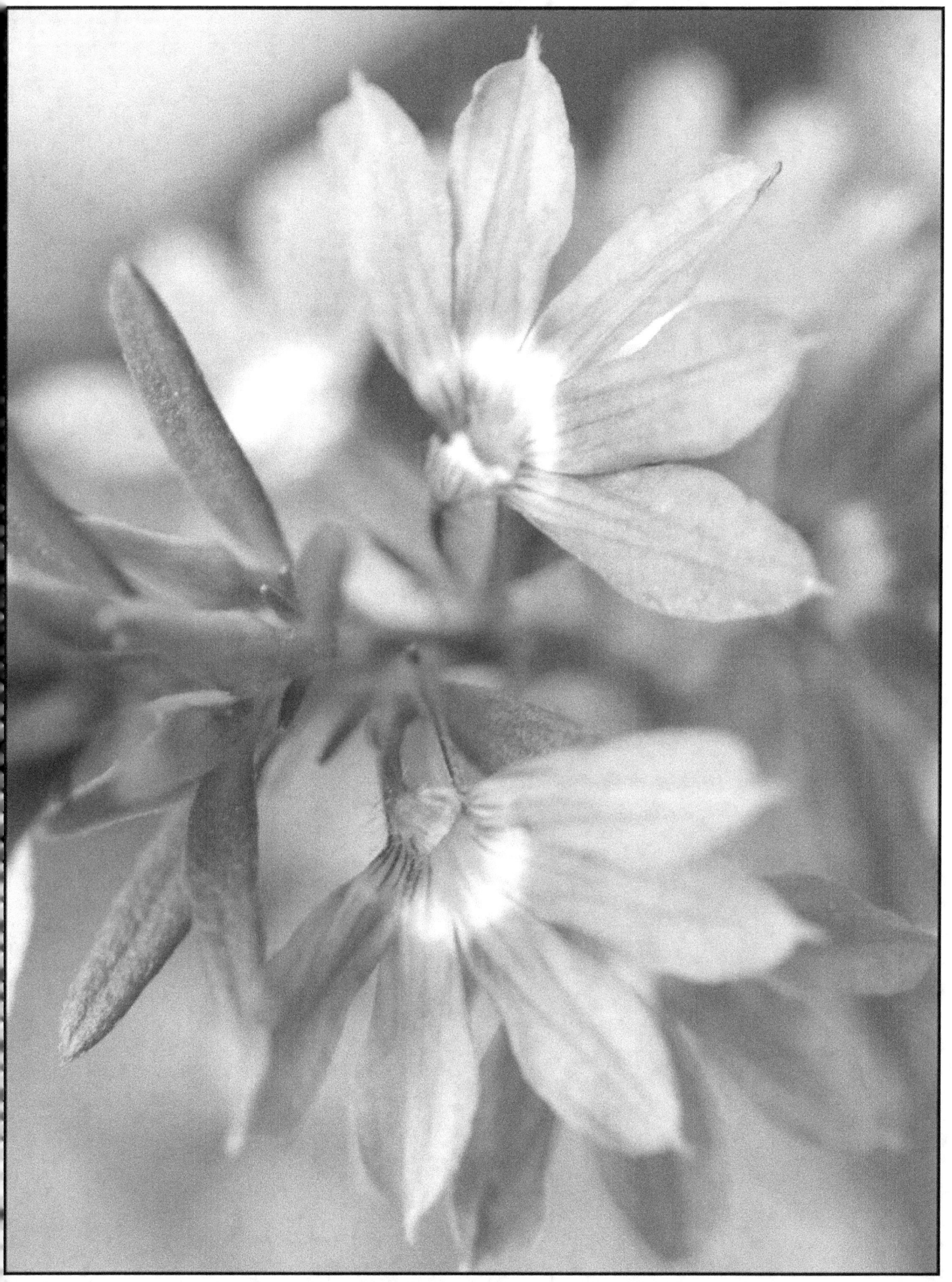

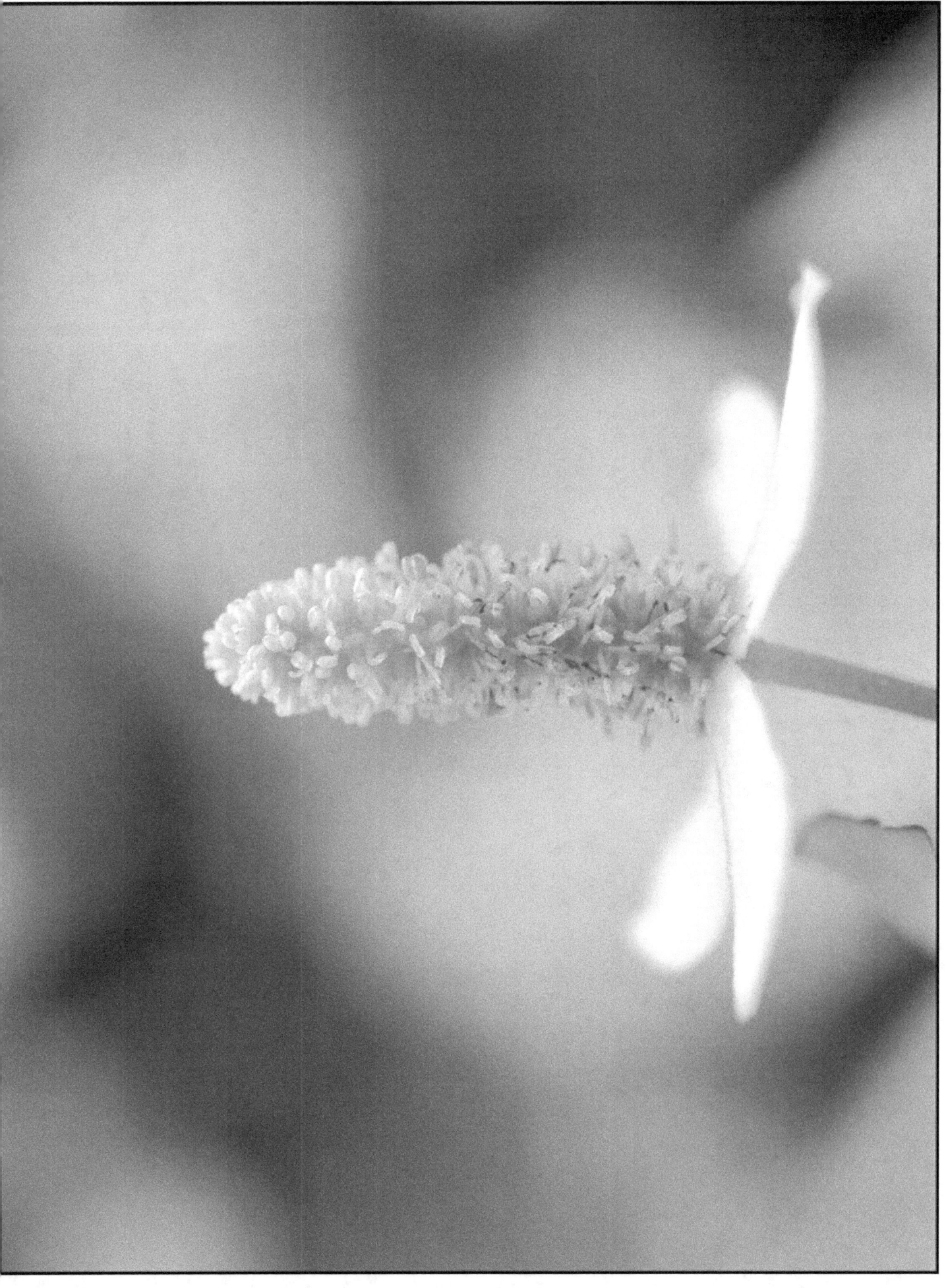

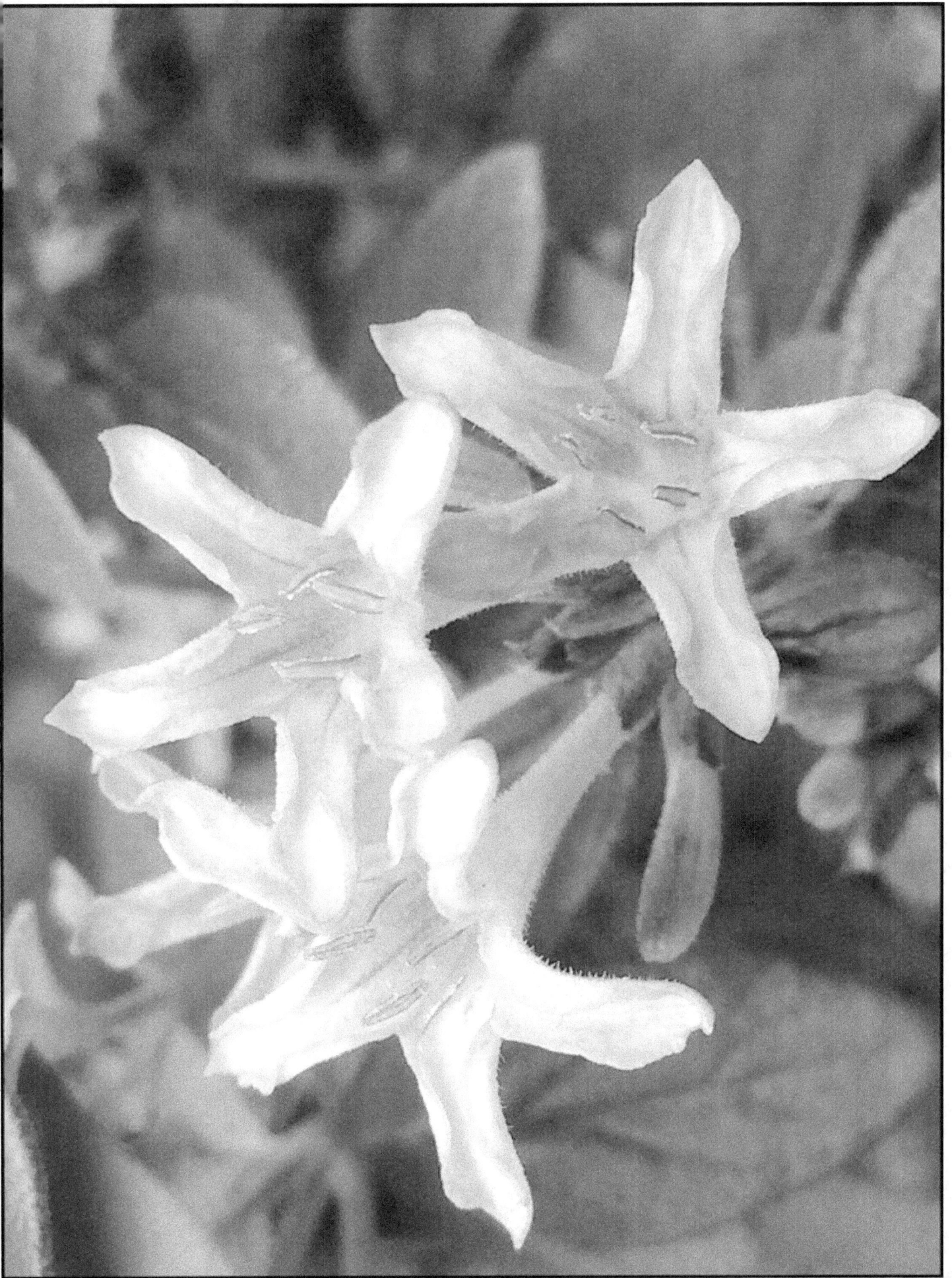

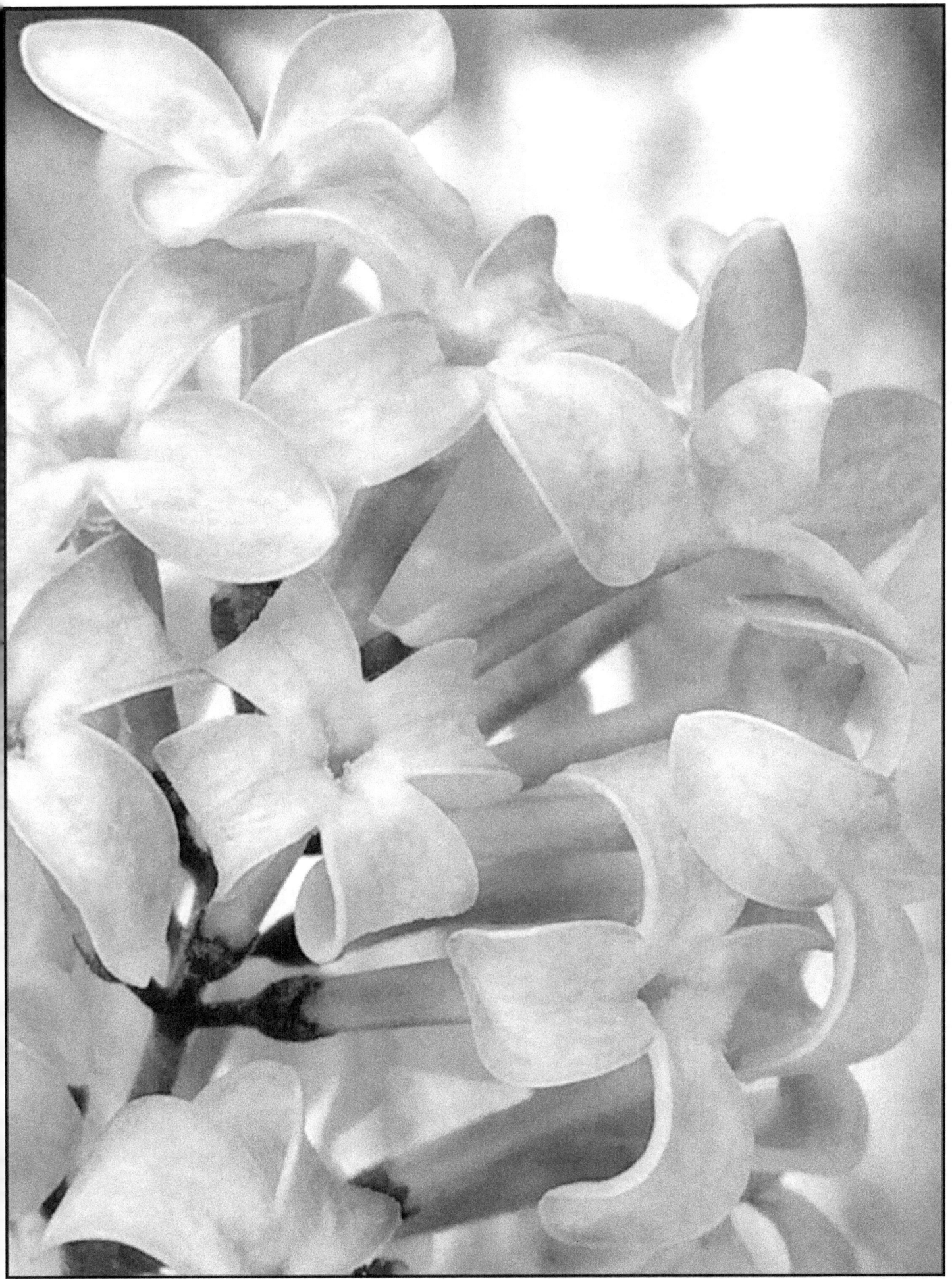

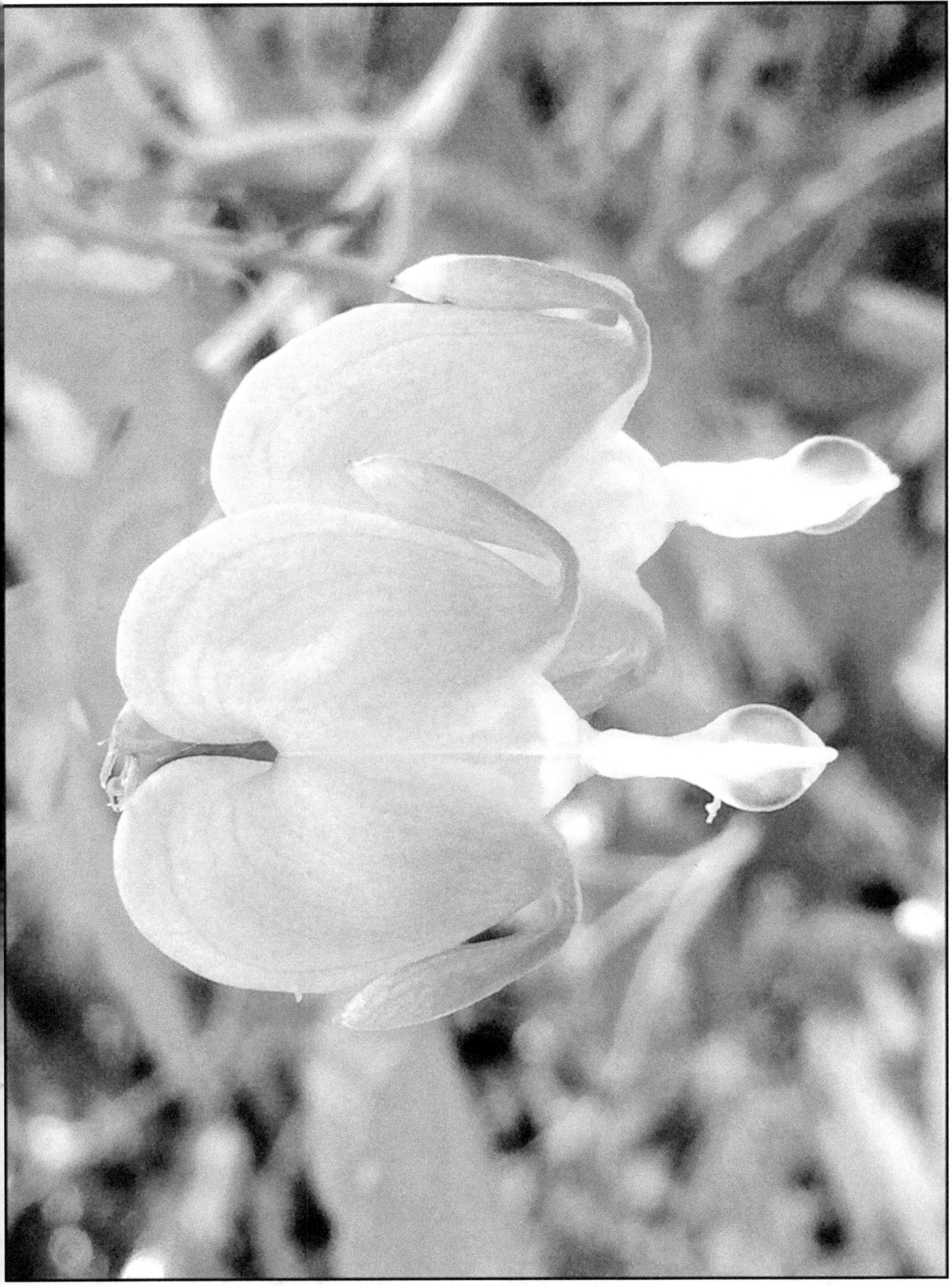

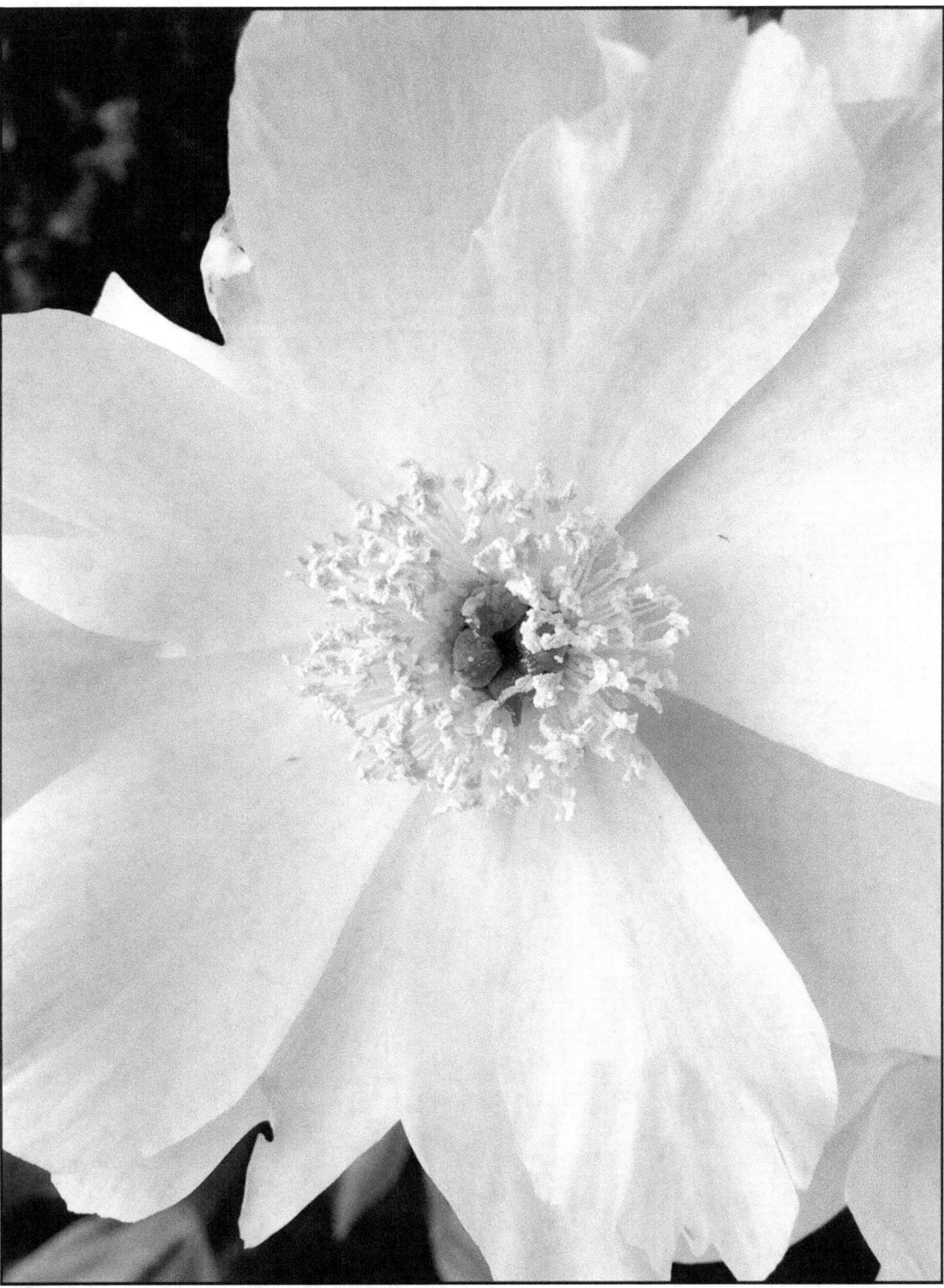

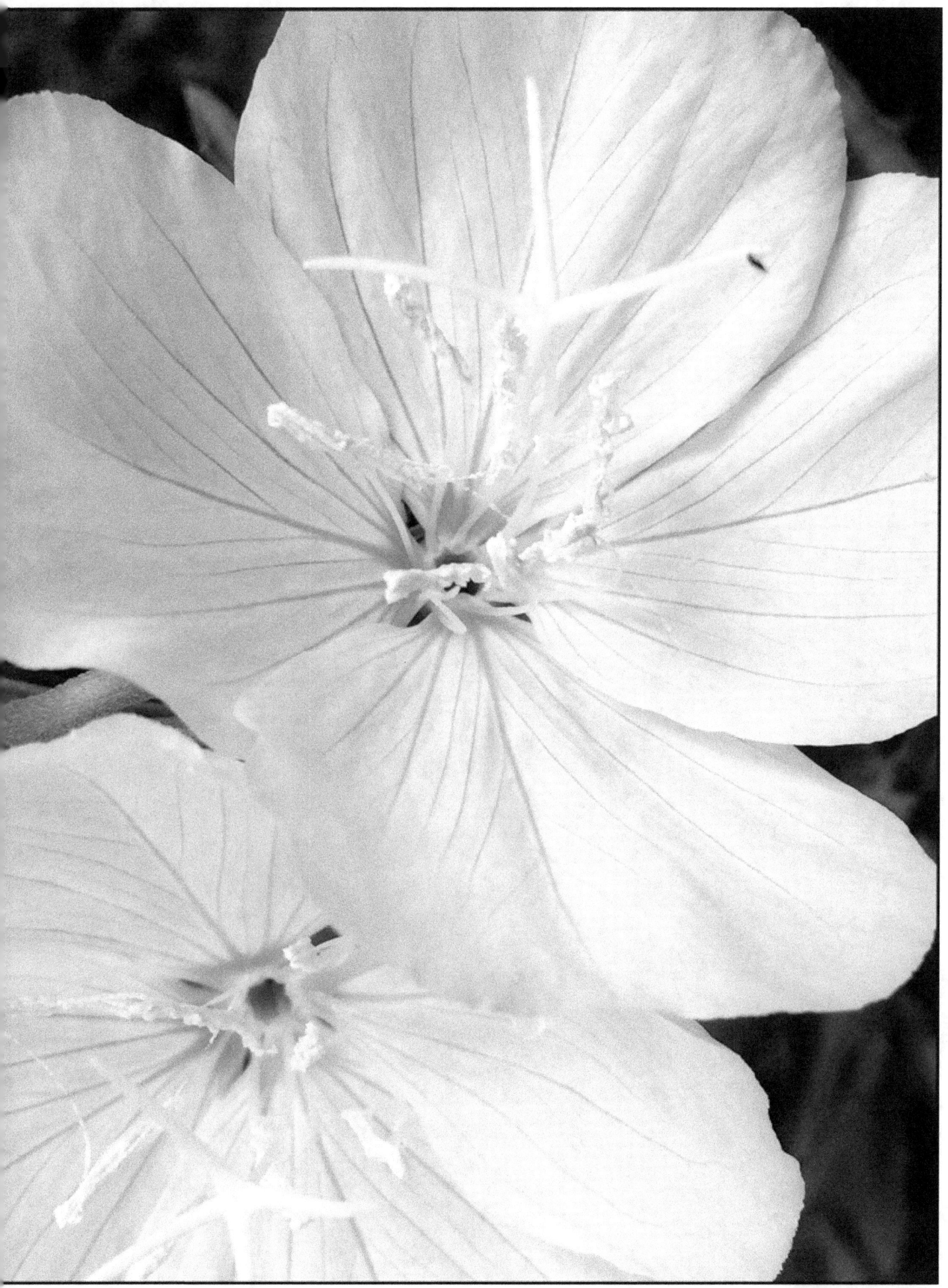

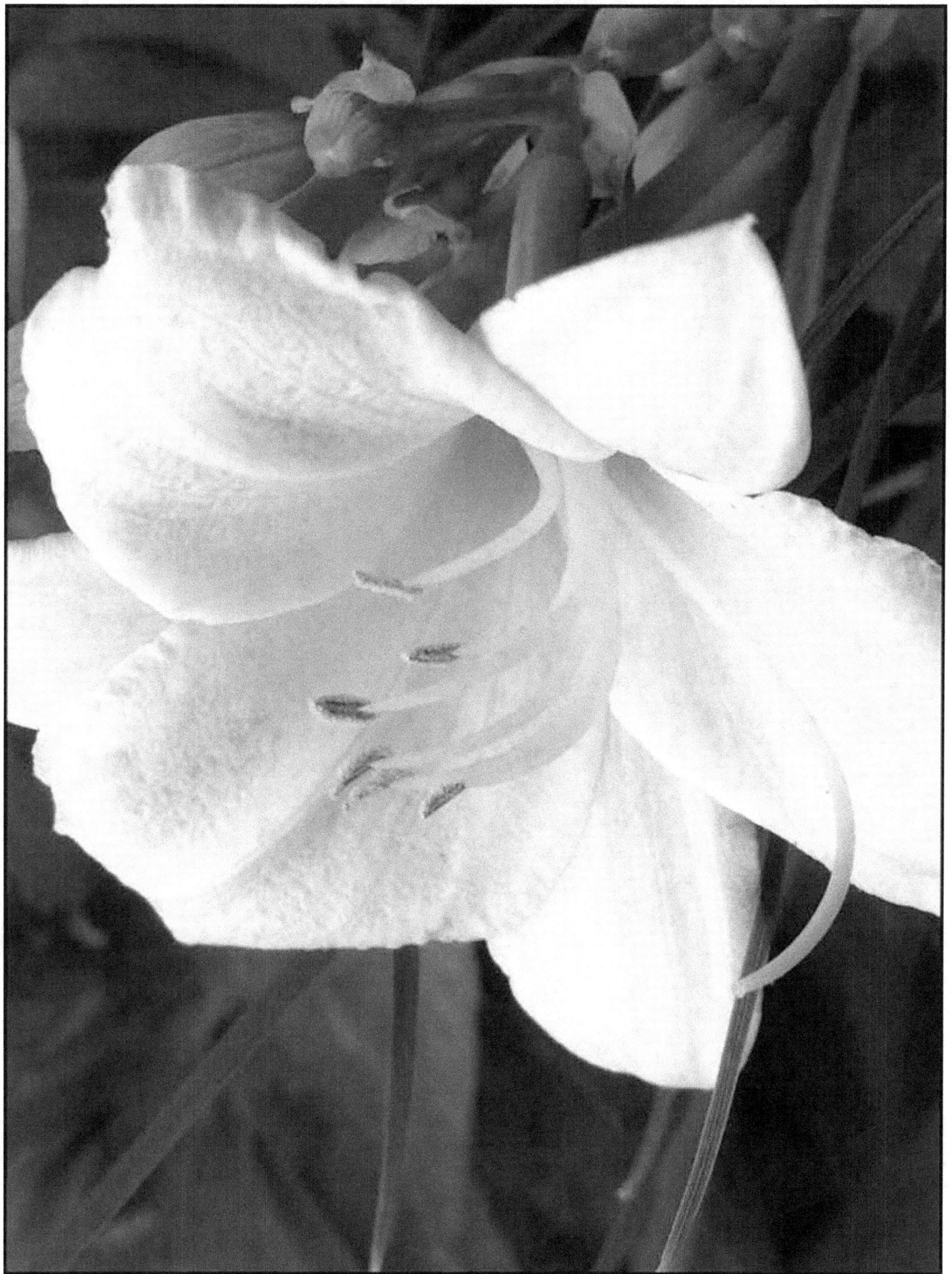

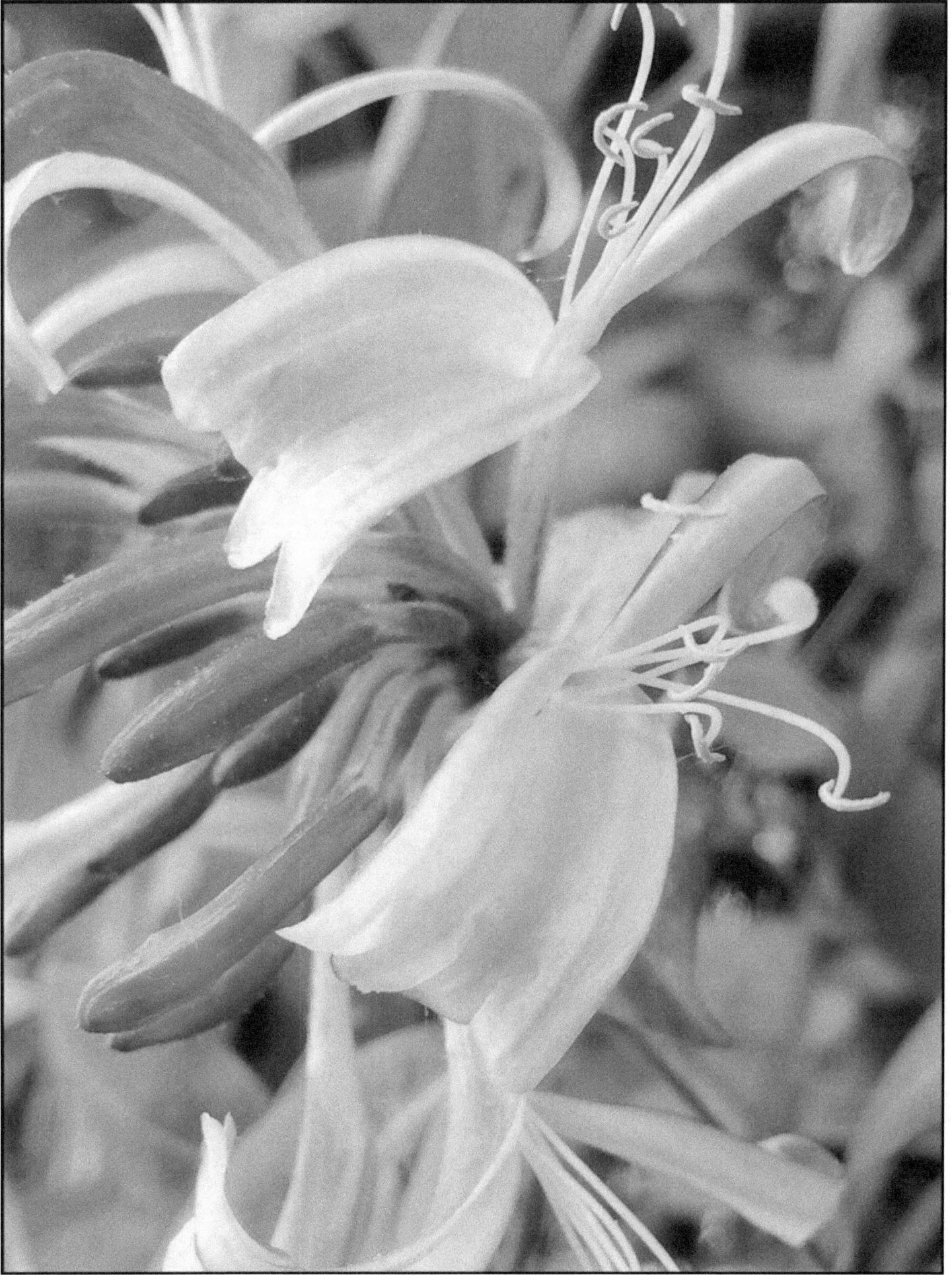

About the Author

Ronda Francis is an amateur photographer with 36 years experience in nature and flower closeup and macro photography. Coupled with her love of gardening, she has taken thousands of photos from her many flower beds, as well as while hiking through the woodlands surrounding her home.

Ronda's other interests include coloring, gardening, various arts and crafts, and cooking. She and her husband of 36 years share their home with their five beagles.

Grayscale images Copyright © 2019 by Ronda Francis
All rights reserved

ISBN-13:

978-1690013303

Printed by Kindle Direct

www.ingramcontent.com/pod-product-compliance
Lightning Source LLC
Chambersburg PA
CBHW081455220526
45466CB00008B/2652